I CAN DRAW
GRAPHIC NOVELS

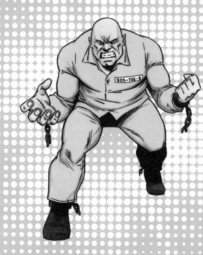

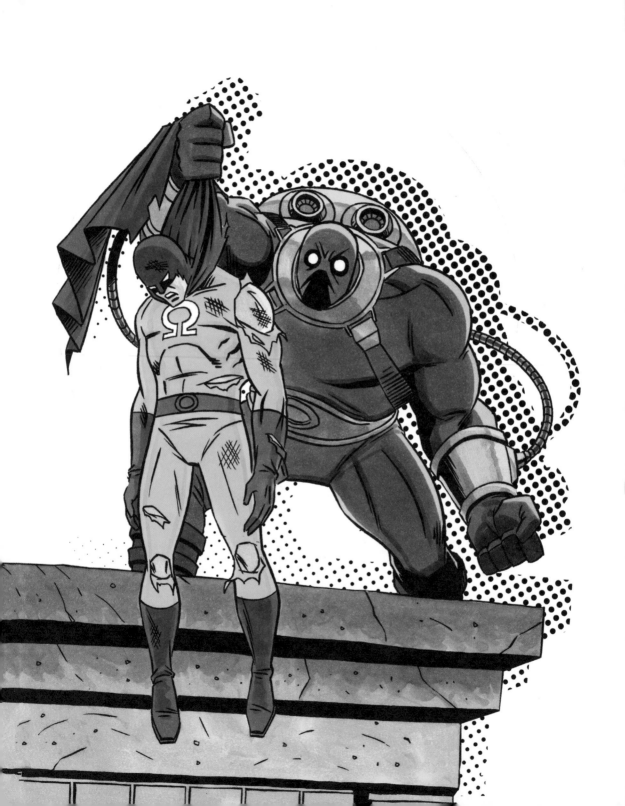

I CAN DRAW
GRAPHIC NOVELS

STEP-BY-STEP TECHNIQUES, CHARACTERS, AND EFFECTS

JUAN CALLE
WILLIAM POTTER
& FRANK LEE

SIRIUS

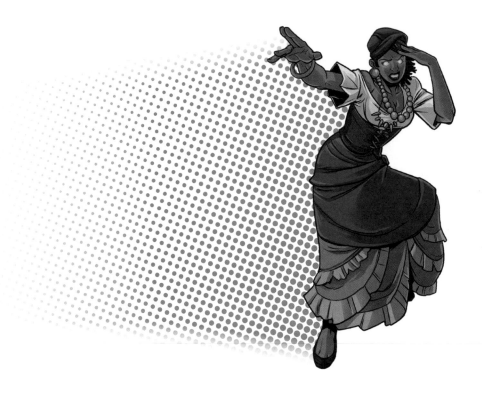

SIRIUS

This edition published in 2022 by Sirius Publishing, a division of
Arcturus Publishing Limited,
26/27 Bickels Yard, 151–153 Bermondsey Street,
London SE1 3HA

ISBN: 978-1-3988-1499-8
AD008596US

Printed in China

CONTENTS

INTRODUCTION

Comic books have been around since the early 1900s, and have grown in popularity ever since. The concept of graphic novels dates from the 1960s. Both formats have thrilled fans with stories about superheroes, bizarre science fiction, crime thrillers, wild west adventures, and almost any subject you can think of.

Both comic books and graphic novels use a sequence of illustrated panels to tell a story. While comic books are published over a series of issues, a graphic novel is usually one complete story. Drawing comic book art is one of the most sought-after jobs in the world of illustration, and it's easy to understand why. What could be more exciting than creating amazing images and telling fantastic stories to inspire readers all over the world?

In this book, we will take you through the stages of creating your first comic book or graphic novel, from choosing your characters to plotting the story in panels, and even producing an incredible cover. There are great tips on how to ink and color your artwork and the best drawing tools to use.

By the end, we hope you'll be inspired to write and illustrate your own comic book. So, what are you waiting for? Turn the page and start creating some exciting comic book art!

HOW TO USE THIS BOOK

This book will take you through the process of creating a graphic novel or comic book. It starts with drawing characters, then shows you how to get them into action. You'll learn how to plot your story and create compelling pages. At the end of each sequence there is a grid with an outline or space to practice so you can draw up your own figure or sequence from scratch and practice your skills.

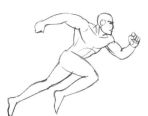
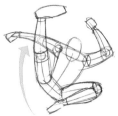

1 Learn how to create different characters.

2 Draw in the detail and color them in.

3 Work out how to make them move dynamically.

4 Use our tips and tricks to show action effectively.

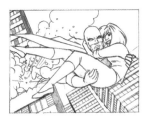
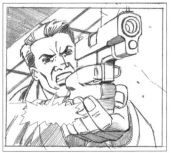
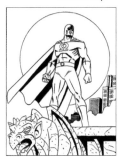

5 Learn what makes a story work effectively.

6 Draw different types of stories from sci-fi to detective stories.

7 Create an attention-grabbing cover for your story.

PRACTICE PAGES

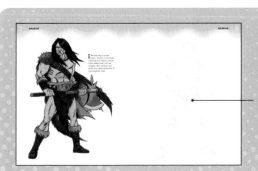

The book guides you through how to draw different aspects of graphic novels from character creation to planning storyboards and creating effective action sequences. Most sections are accompanied by practice pages that allow you to practice the elements that have just been discussed. With character drawing, a basic outline is given, so you can add your own details on top of it.

THE BASICS

Let's start with the essentials—the tools of the trade. Without them, there will be no cool pictures in your comic book!

Brushes

Some artists like to use a fine brush for inking linework. This takes a bit more practice and patience to master, but the results can be very satisfying. If you want to try your hand at brushwork, you will definitely need to get hold of some good quality sable brushes.

Pencils

It's best not to cut corners on quality here. Get a good range of graphite (lead) pencils ranging from soft (6B) to hard (6H).

Hard lead lasts longer and leaves less graphite on the paper. Soft lead leaves more lead on the paper and wears down more quickly. Every artist has their personal preference, but 2H pencils are a good medium range to start out with until you find your favourite.

Spend some time drawing with each weight of pencil and get used to their different qualities. Another good product to try is the clutch, or mechanical pencil. These are available in a range of lead thicknesses, 0.5mm being a good medium range. These pencils are very good for fine detail work.

Pens

There is a large range of good quality pens on the market these days and all will do a decent job of inking. It's important to experiment with different pens to determine which you find most comfortable.

You may find that you end up using a combination of pens to produce your finished piece of artwork. Remember to use a pen that has watertight ink if you want to color your illustration with a watercolor or ink wash. It's quite a good idea to use one of these anyway. There's nothing worse than having your nicely inked drawing ruined by an accidental drop of water!

Markers

These are very versatile pens and, with practice, can give pleasing results.

Inks

With the dawn of computers and digital illustration, materials such as inks have become a bit obscure, so you may have to look harder for these but most good art and craft shops should stock them.

French curves
These are available
in a few shapes and
sizes and are useful for
drawing curves.

Eraser
There are three main types of eraser:
rubber, plastic and putty. Try all three
to see which kind you prefer.

Circle template
This is very useful for
drawing small circles.

TYPES OF PAPER

The array of paper that is available can seem confusing
when you're choosing a surface for your art. Your paper
selection will depend on how you want your final piece to be
used. Thicker papers are best for presentation pieces and
posters and add a high-quality finish to your piece.

Try feeling the thickness of papers by taking the corner
between your thumb and middle finger and gently flicking
your forefinger across the corner of the paper. If you do this with
different papers, you will soon develop a feel for the various weights.

LAYOUT PAPER
Any piece of paper can be used
as your layout paper. Inexpensive
paper is the best choice as you will
be using this paper for planning
out your ideas and maybe doing
sketches of heads, bodies, or even
hand poses before you decide on
your final piece of art.

WATERCOLOR PAPER
If your final piece is to be colored,
watercolor paper is the best
choice as it holds color well with
very little bleeding from your
original lines. It's available with
a choice of surfaces—smooth,
slightly textured and highly
textured—and you can use
whichever appeals.

CARTRIDGE PAPER
Paper for drawing can vary in price
from expensive, extremely high
quality ranges to more cheaply
produced pads. Price is not always
an exact guide to a better paper,
though, and buying the most
expensive paper will not make the
lines you put on it any better!

DRAWING FIGURES: BASIC SHAPES

A simple, but very effective way of drawing human (or super-human!) figures is to draw a stick figure and then build on it using a selection of basic shapes such as cylinders, balls, cubes, and spheres. Learning how to give 3-D form to simple shapes (like the ones below) is the secret to drawing life-like figures.

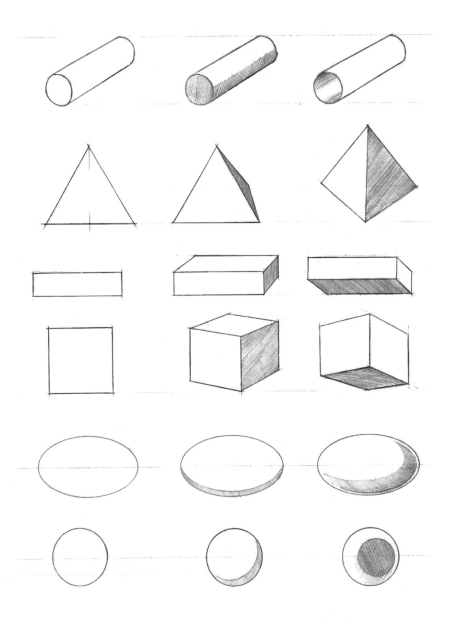

CONSTRUCTION SHAPES

Here is how to build the human figure by starting with a stick figure, then building on it using basic shapes. Whatever pose you want to draw your character in, once you have learnt this step-by-step technique, you'll have the skills you need to draw realistic-looking figures with ease.

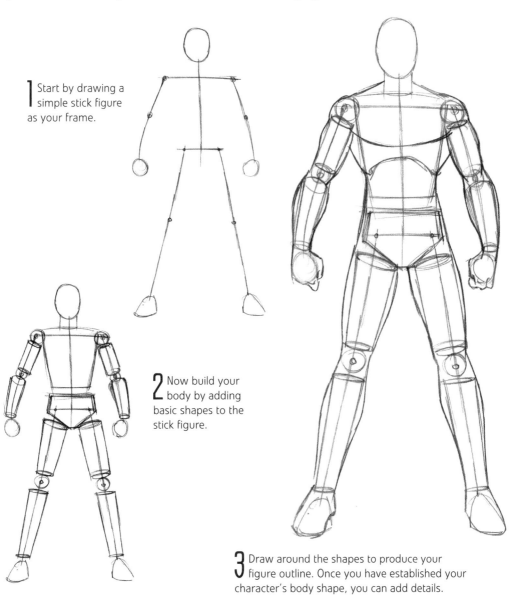

1 Start by drawing a simple stick figure as your frame.

2 Now build your body by adding basic shapes to the stick figure.

3 Draw around the shapes to produce your figure outline. Once you have established your character's body shape, you can add details.

DRAWING THE HUMAN HEAD

The human head can be mapped out using a square-shaped grid (see right). This example is based on a standard-sized head, but you can alter these proportions when creating characters with a different look, such as monsters or supernatural beings.

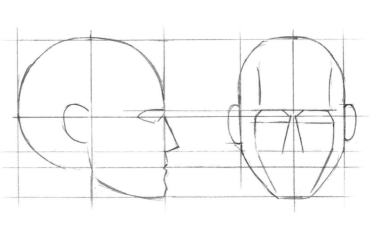

To draw a human head, first divide the square into quarters. Position the eyes in the middle on the centre line. The nose should be placed in the third quarter, then draw the ears at the same level. Draw the mouth in the middle of the bottom quarter in your grid.

PRACTICE

DRAWING THE HUMAN HEAD

Use this page to practice variations on the head as shown opposite.

PERSPECTIVE

Drawing superheroes and other exciting characters is a lot of fun, but it's only one part of the process of creating a comic book. You need to create a world for your characters to inhabit. To make your scenery realistic and believable, a basic knowledge of perspective is necessary.

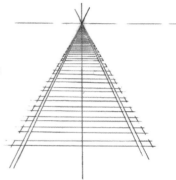

Vanishing point and horizon line

Study the diagram of a train track, right. Notice how the rails get closer together the further they go into distance. The point where the lines join is called the vanishing point. The horizontal line in the distance is called the horizon line. The horizon line is the viewer's eye level.

Plotting perspective

Let's take a simple cube (below left) and look at how the rules of perspective apply.

Turn the cube so you are looking at it straight-on (below right). Draw a line down the middle. Notice that the two sides on the top appear to be drawing closer together towards the back.

If we continue these lines, they will eventually meet (bottom left). The point at which they meet determines the horizon line. This is called a one-point perspective because the lines meet at a single point (bottom right).

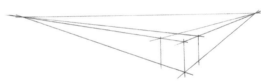

When we turn the cube so we are looking directly at one of the corners, we get a two-point perspective (above). This means there are two vanishing points.

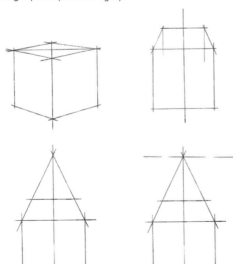

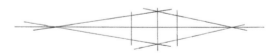

Here is the cube from above, with the horizon line cutting through its centre (above). If we follow the converging lines to their ultimate meeting point, again, we get a two-point perspective.

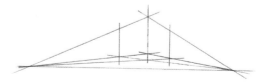

The same applies if we view the cube from below.

This scene has been
drawn using a one-
point perspective.

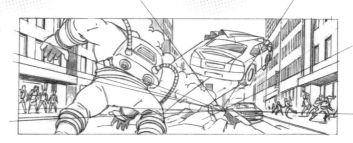

Another example
of a two-point
perspective.

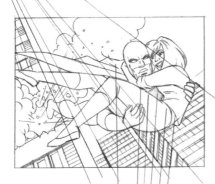

This example has a
two-point perspective.

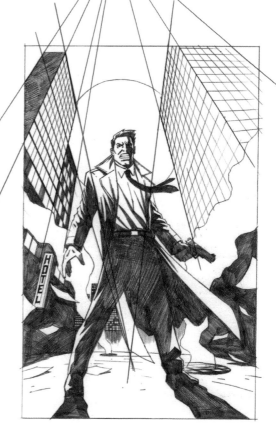

Applying perspective

Here are some examples of how to apply the
rules of perspective to graphic book panels. Even
though it's tricky, it's important to try to get
the perspective right. To make your scenes look
realistic, all of the elements in the foreground,
background, and centre of your page must be
positioned correctly.

When you have multiple vanishing points,
attach another sheet of paper to your drawing,
so that you can continue the perspective lines off
the page to get them just right.

CREATING CHARACTERS

The hero... champion of the people, righter of wrongs, protector, avenger, and saviour. Who will you choose to play the starring role in your story? Will your hero be super-powered and bullet proof? Will they just be an ordinary guy or girl with the heart and bravery of a lion in the face of danger? In this section we'll show you lots of different types of character to help you decide what sort of hero you want to create.

Superhero

Will you choose a superhero to be at the centre of your story? Will he have the power of flight or be able to reach the top of tall buildings in a single leap? Will he be faster than a speeding bullet, or have x-ray vision? Superheroes with super powers are made all the more interesting and complex if they have a flaw or weakness that makes them vulnerable and capable of being defeated or destroyed. What weakness might you give your superhero?

Sci-fi cyborg

You could choose to set your story in the future, where advances in science and technology have reshaped the world. The cyborg is a futuristic hybrid between man and machine, a super-soldier with enhanced strength, speed and sight. Science fiction is very popular in comic books. Most superheroes owe their powers to a freak accident within the world of science fiction.

Warrior

You could choose to give your story a fantasy setting with a brave, powerful warrior as your hero. This guy would win the day by the might of his axe and his brutish strength. The fantasy art genre is filled with all sorts of interesting characters, from warriors and maidens to magical witches, wizards, orcs, and elves—take your pick!

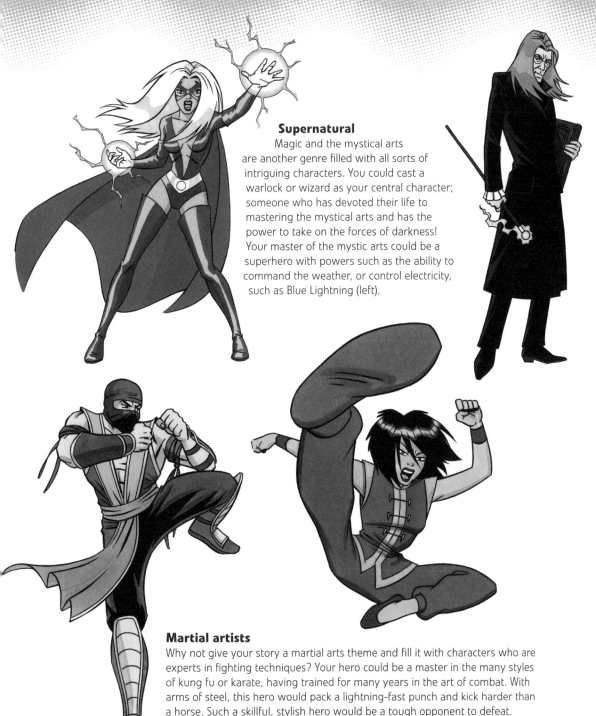

Supernatural

Magic and the mystical arts are another genre filled with all sorts of intriguing characters. You could cast a warlock or wizard as your central character; someone who has devoted their life to mastering the mystical arts and has the power to take on the forces of darkness! Your master of the mystic arts could be a superhero with powers such as the ability to command the weather, or control electricity, such as Blue Lightning (left).

Martial artists

Why not give your story a martial arts theme and fill it with characters who are experts in fighting techniques? Your hero could be a master in the many styles of kung fu or karate, having trained for many years in the art of combat. With arms of steel, this hero would pack a lightning-fast punch and kick harder than a horse. Such a skillful, stylish hero would be a tough opponent to defeat.

Unassuming hero

Not all heroes are muscle-bound with super powers. Some of the most captivating characters are just ordinary people who are thrown into an extraordinary situation. Some heroes possess nothing more than a fearless heart to stand tall against the forces of evil and the intelligence to outwit their enemies.

Western

Yee-haw! You could choose to set your story in the pioneering days of America and include gunfights, horse chases and big, sweeping untamed landscapes. There have been many heroes of the Wild West. It's not just the villains who may wish to conceal their identity.
Perhaps your hero is someone who leads a dual life, a character who blends in to the crowd and tries not to draw attention to himself, but by night wages war on the corrupt and evil.

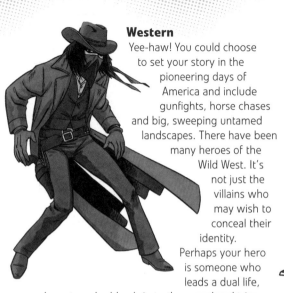

Anti-hero

Perhaps your hero will be an anti-hero, a character out for nothing more than his own gain, whatever that might be. He could be a Robin Hood style character who steals only from the rich, but whether he gives to the poor—that's for you to decide... Or your hero could be a soldier of fortune—a mercenary whose skills are available to the highest bidder. Anti-heroes are more popular in comic books now, and the line between good and evil is becoming increasingly blurred.

Good cop

Crime comics offer a gritty realism where tough, cynical cops dish out justice to even tougher criminals in cities that are overflowing with crime and corruption. Characters in this genre are often complex. The relationships and loyalties between cops and criminals are often intertwined, making it hard to know who to trust.

Character Variations

Here are some examples of other types of hero you could choose to create.

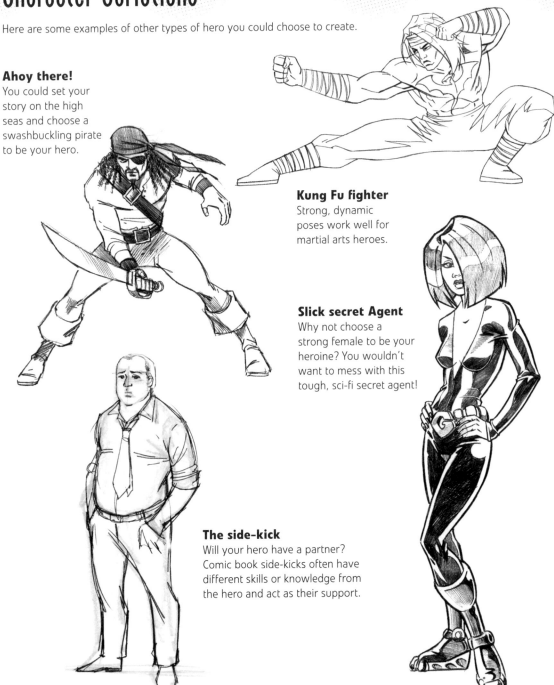

Ahoy there!
You could set your story on the high seas and choose a swashbuckling pirate to be your hero.

Kung Fu fighter
Strong, dynamic poses work well for martial arts heroes.

Slick secret Agent
Why not choose a strong female to be your heroine? You wouldn't want to mess with this tough, sci-fi secret agent!

The side-kick
Will your hero have a partner? Comic book side-kicks often have different skills or knowledge from the hero and act as their support.

WARRIOR

Over the next four pages you'll learn how to draw a warrior hero. You could choose to adapt and develop this figure to create your own central character. Even if you want your hero to look very different, the step-by-step technique you'll learn can be applied to any figure. Once you have learnt the basic construction of a human form, you can build any character using the initial frame.

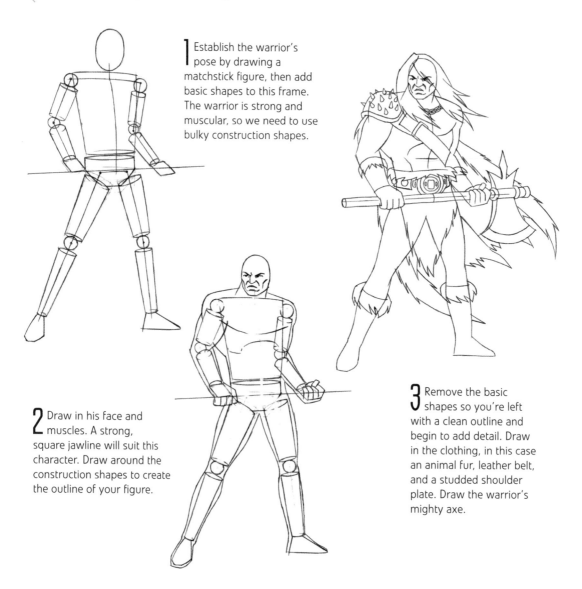

1 Establish the warrior's pose by drawing a matchstick figure, then add basic shapes to this frame. The warrior is strong and muscular, so we need to use bulky construction shapes.

2 Draw in his face and muscles. A strong, square jawline will suit this character. Draw around the construction shapes to create the outline of your figure.

3 Remove the basic shapes so you're left with a clean outline and begin to add detail. Draw in the clothing, in this case an animal fur, leather belt, and a studded shoulder plate. Draw the warrior's mighty axe.

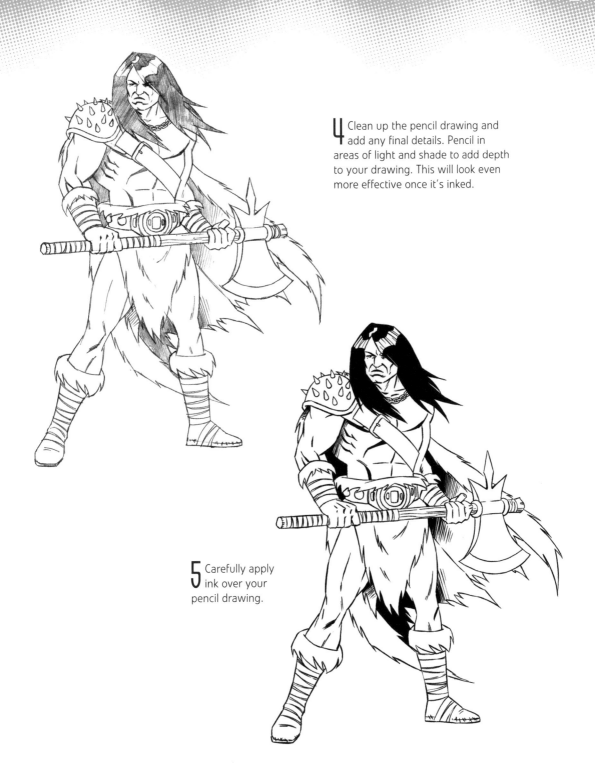

4 Clean up the pencil drawing and add any final details. Pencil in areas of light and shade to add depth to your drawing. This will look even more effective once it's inked.

5 Carefully apply ink over your pencil drawing.

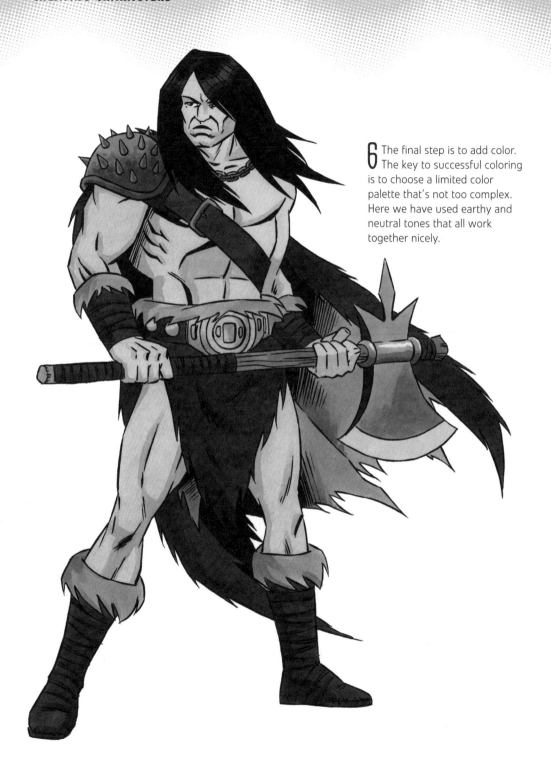

6 The final step is to add color. The key to successful coloring is to choose a limited color palette that's not too complex. Here we have used earthy and neutral tones that all work together nicely.

PRACTICE

Use this basic outline to build
your own heroic character.

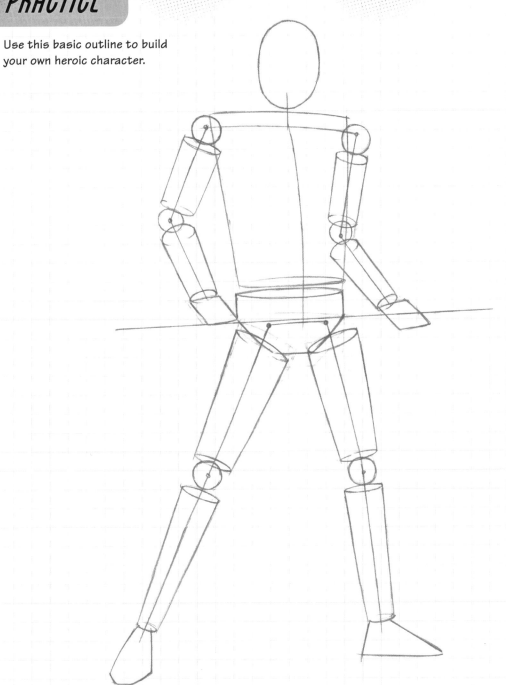

CREATING VILLAINS

For every hero trying to save the world, there's a villain scheming to dominate it! Without bad guys there would be no need for heroes—we need the balance of good and evil in our stories to make them interesting.

Comic book villains come in all shapes and sizes. Take a look at the collection of baddies on the following pages—hopefully they will inspire you to create your own supervillain!

Everyone loves a good bad guy! You might include lots of them in your story, but for a baddy to rise up the ranks and be crowned a supervillain they must be powerful, ruthless, evil and often crazy!

Your villain's evil motives and actions are crucial to the plot of your story. What sort of bad guy will your hero be up against? Let your imagination run wild as you create your own monstrous maniac!

Supernatural

Supernatural themes in comic books offer great opportunities to create ghoulish characters who defy the laws of science and nature.

Your villain could be a crazed creature who has risen from the grave, seeking revenge… or a dark force of evil from a supernatural dimension capable of controlling space and time.

Victorian villain

You could give your story a historical setting and explore another era. Think of the dark drama you could create in the smoky, lamplit streets of Victorian London, for example. You'll need to research your costumes and scenery to get the atmosphere right.

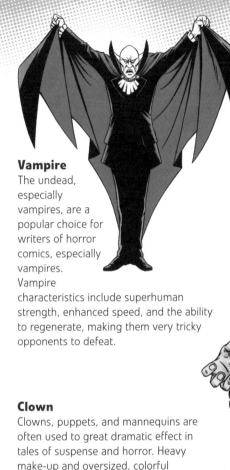

Magician

Your villain could be a crazy conjuror with dark, magical powers. Such an evil illusionist could create many mind-bending obstacles for your hero. Their skills include telepathy, teleportation, energy blasts, and the creation of protective force fields.

Vampire

The undead, especially vampires, are a popular choice for writers of horror comics, especially vampires. Vampire characteristics include superhuman strength, enhanced speed, and the ability to regenerate, making them very tricky opponents to defeat.

Escaped convict

A crazed convict who has escaped from prison makes a good villain. This guy's raw strength and cold-blooded nature make him a danger to society, but will you choose brawn over brains? Which is more powerful? Your villain doesn't have to be physically strong—a brilliant mind can be harder to defeat.

Clown

Clowns, puppets, and mannequins are often used to great dramatic effect in tales of suspense and horror. Heavy make-up and oversized, colorful costumes mask the true emotions and intentions of the performer, which can be unnerving.

The brightly-painted, jolly face of a clown can suddenly take on a highly sinister appearance when it masks the face of a fiend.

Maniacal monster

Huge, supercharged behemoths who rampage through the story causing mass mayhem and destruction are always welcome in comic books. They guarantee explosive action and good battle scenes for the hero.

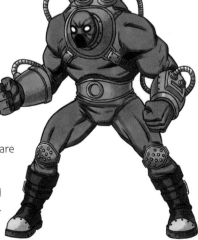

Mad scientist

Crazy professors locked away in their laboratories mixing lethal chemicals, designing deadly weapons or creating superhuman creatures can be great fun to build into your story. What will your mad scientist unleash upon an unsuspecting world?

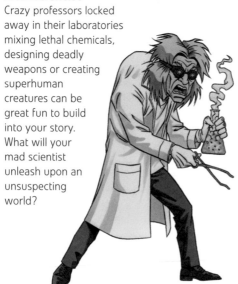

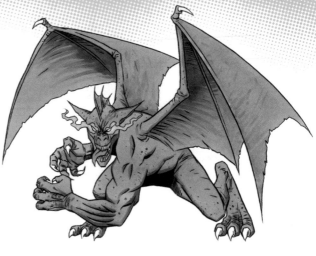

Dragon

Villains don't always come in human form. You might want to create a more physically imposing monster for your story.

Your hero's source of danger could be a demon, or an ancient creature who has been summoned to destroy the planet after centuries of slumber.

Wicked queen

You could give your story a medieval setting and create a kingdom ruled by an evil, powerful king or queen.

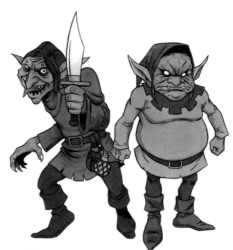

Goblins

Your supervillain might need some accomplices to carry out his master plan. Goblins and elves can add moments of humour to a story as well as horror and suspense.

Although diminutive in size and easily overpowered in battle, their sly, cunning abilities are often underestimated by the hero.

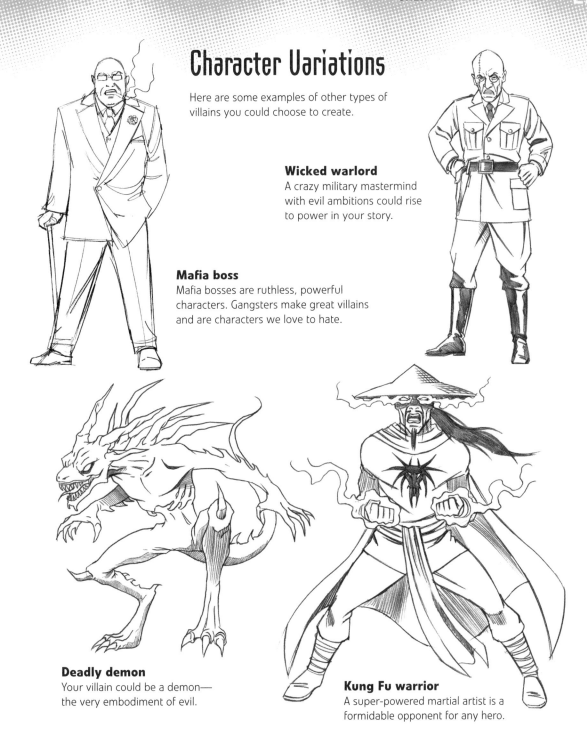

Character Variations

Here are some examples of other types of villains you could choose to create.

Wicked warlord
A crazy military mastermind with evil ambitions could rise to power in your story.

Mafia boss
Mafia bosses are ruthless, powerful characters. Gangsters make great villains and are characters we love to hate.

Deadly demon
Your villain could be a demon—the very embodiment of evil.

Kung Fu warrior
A super-powered martial artist is a formidable opponent for any hero.

ESCAPED CONVICT

In this section you'll learn how to draw two very different villains. Whatever form your villain takes, the technique of building up a figure using basic shapes can be adapted and applied when creating your own character.

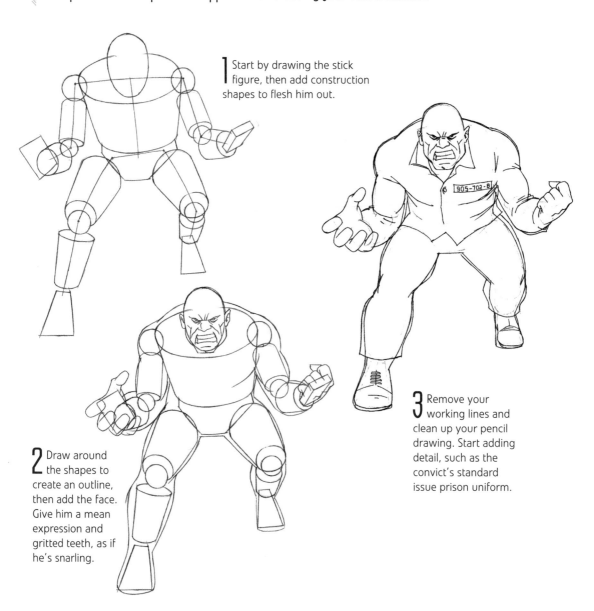

1 Start by drawing the stick figure, then add construction shapes to flesh him out.

2 Draw around the shapes to create an outline, then add the face. Give him a mean expression and gritted teeth, as if he's snarling.

3 Remove your working lines and clean up your pencil drawing. Start adding detail, such as the convict's standard issue prison uniform.

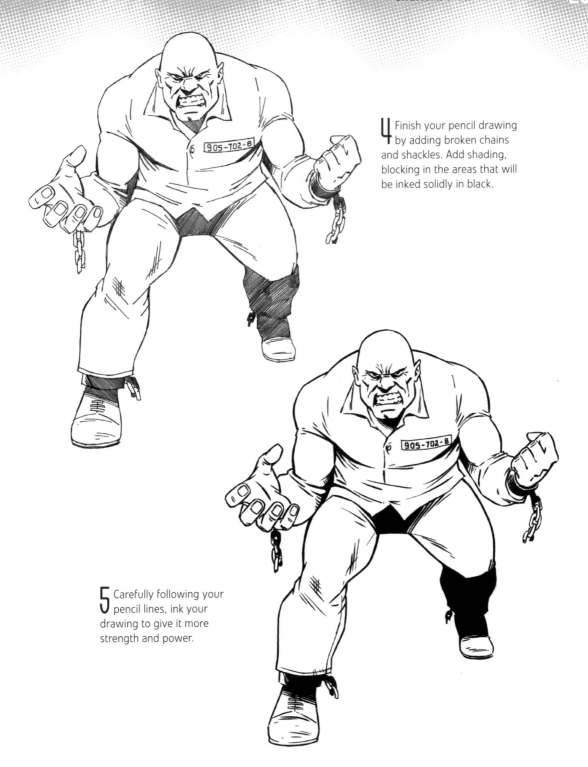

4 Finish your pencil drawing by adding broken chains and shackles. Add shading, blocking in the areas that will be inked solidly in black.

5 Carefully following your pencil lines, ink your drawing to give it more strength and power.

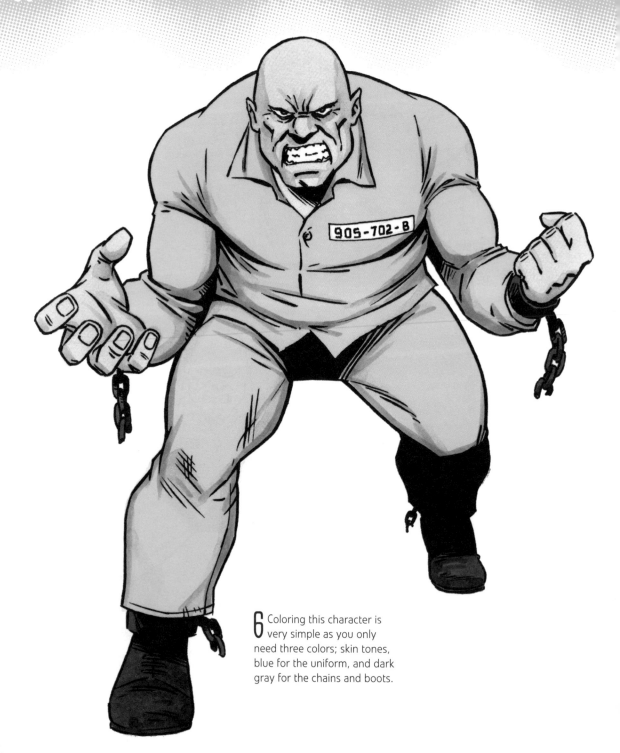

6 Coloring this character is very simple as you only need three colors; skin tones, blue for the uniform, and dark gray for the chains and boots.

PRACTICE

Use this basic outline
to build your own
fearsome villain.

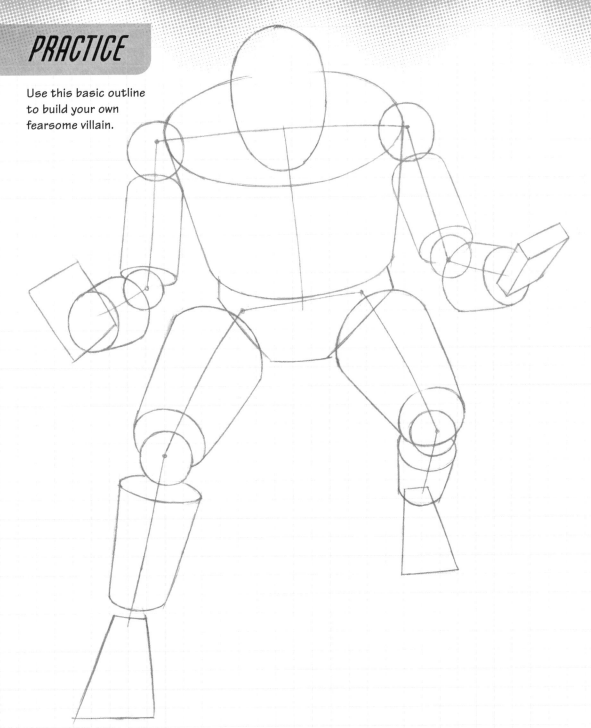

MAD SCIENTIST

Skinny and charged with demented energy, the mad scientist is quite a different villain from the bulky convict. Concentrate on conveying his deranged creativity as expressed in the way he uses his body. Dynamic facial expressions also help to capture this character's madness.

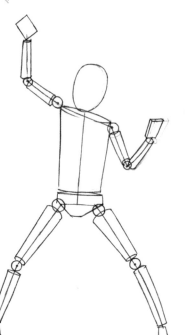

1 Start to draw the figure using the stick frame and construction shapes.

3 Clean up your pencil work and draw the clothing. We've chosen a classic lab coat for this nutty professor. Draw the bubbling potion he is holding.

2 Draw the face and hair. Give this character an exaggerated, crazed expression that leaves the reader in no doubt that this person is MAD!

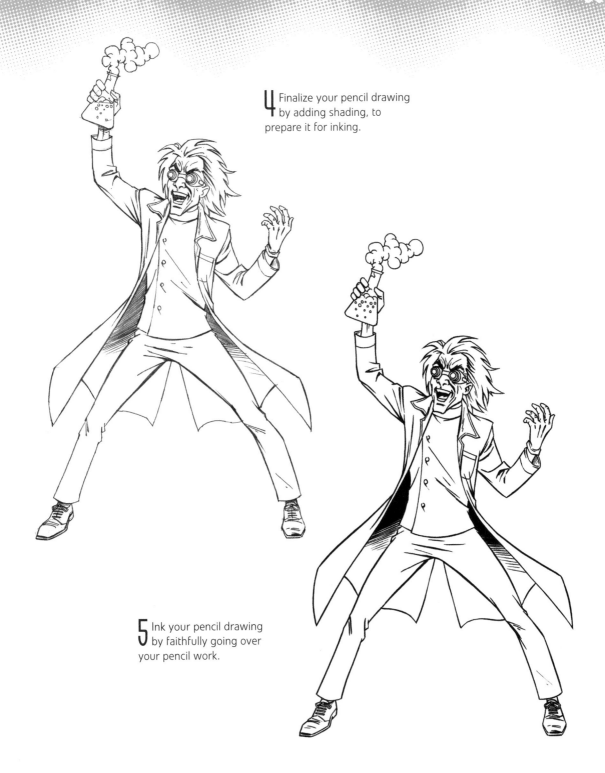

4 Finalize your pencil drawing by adding shading, to prepare it for inking.

5 Ink your pencil drawing by faithfully going over your pencil work.

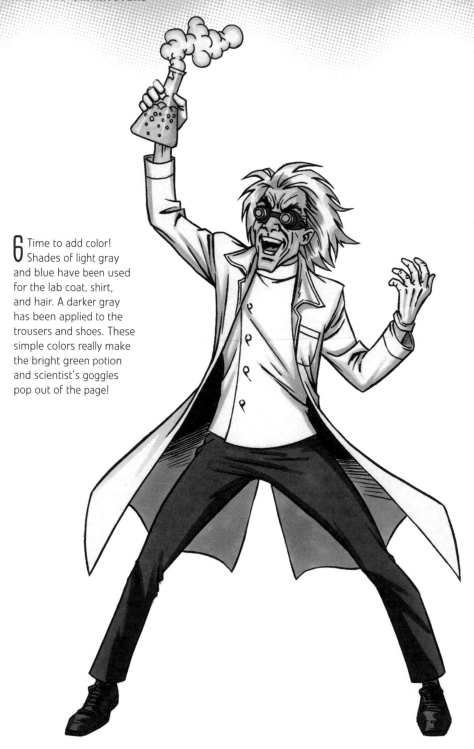

6 Time to add color! Shades of light gray and blue have been used for the lab coat, shirt, and hair. A darker gray has been applied to the trousers and shoes. These simple colors really make the bright green potion and scientist's goggles pop out of the page!

PRACTICE

Use this basic outline
to draw your own
demented scientist.

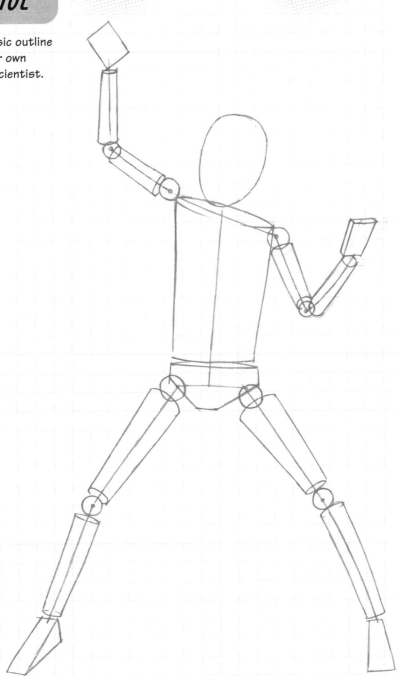

DRAWING ACTION

This chapter is all about action and learning how to make your comic book panels more interesting by animating your characters.

Once you've become familiar with the process of how to construct the human figure, it's time to develop those skills so you can transform simple stances into explosive action poses!

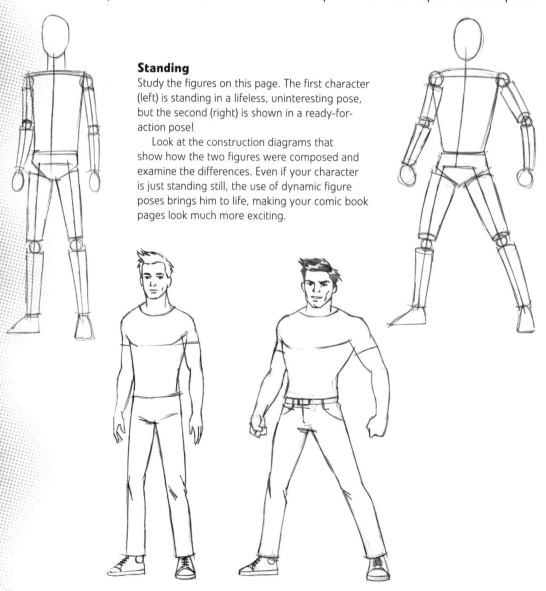

Standing

Study the figures on this page. The first character (left) is standing in a lifeless, uninteresting pose, but the second (right) is shown in a ready-for-action pose!

Look at the construction diagrams that show how the two figures were composed and examine the differences. Even if your character is just standing still, the use of dynamic figure poses brings him to life, making your comic book pages look much more exciting.

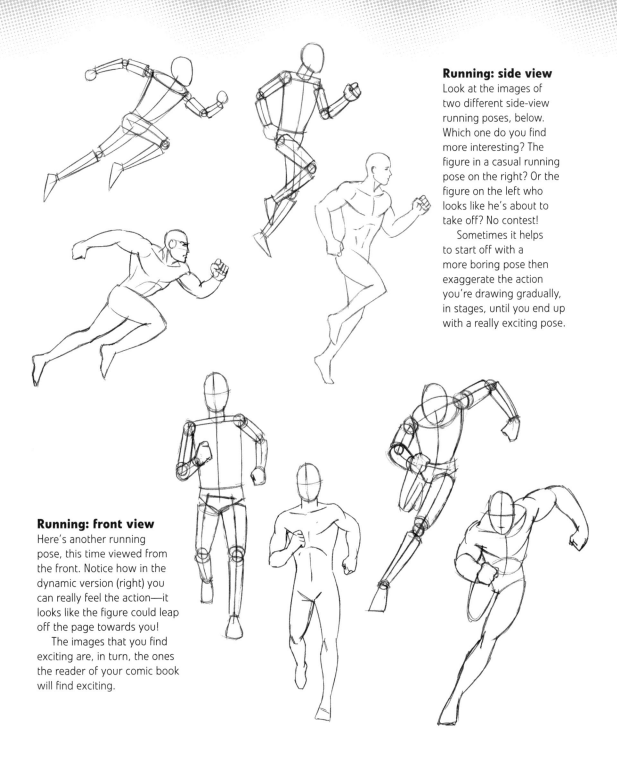

Running: side view

Look at the images of two different side-view running poses, below. Which one do you find more interesting? The figure in a casual running pose on the right? Or the figure on the left who looks like he's about to take off? No contest!

Sometimes it helps to start off with a more boring pose then exaggerate the action you're drawing gradually, in stages, until you end up with a really exciting pose.

Running: front view

Here's another running pose, this time viewed from the front. Notice how in the dynamic version (right) you can really feel the action—it looks like the figure could leap off the page towards you!

The images that you find exciting are, in turn, the ones the reader of your comic book will find exciting.

PRACTICE ACTION

Use these pages to practice drawing a variety of action poses.

PRACTICE ACTION

COMBAT

Dynamic fight sequences are a staple of many comic books and graphic novels whatever their genre. The below techniques show you how to create a sense of power and aggression through the way you construct your figures, as well as a strong sense of direction.

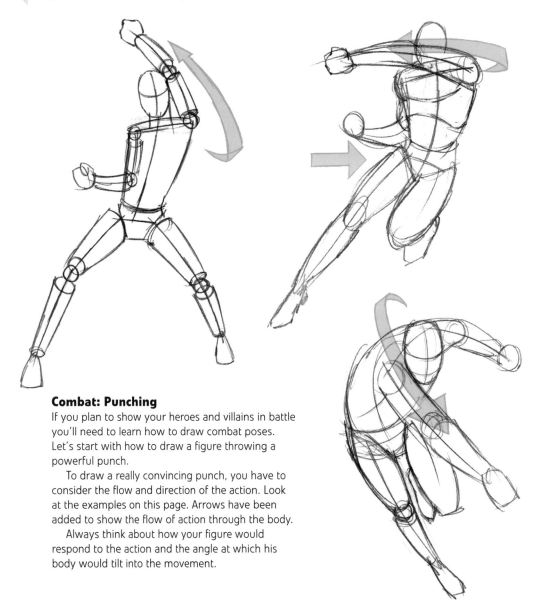

Combat: Punching

If you plan to show your heroes and villains in battle you'll need to learn how to draw combat poses. Let's start with how to draw a figure throwing a powerful punch.

To draw a really convincing punch, you have to consider the flow and direction of the action. Look at the examples on this page. Arrows have been added to show the flow of action through the body.

Always think about how your figure would respond to the action and the angle at which his body would tilt into the movement.

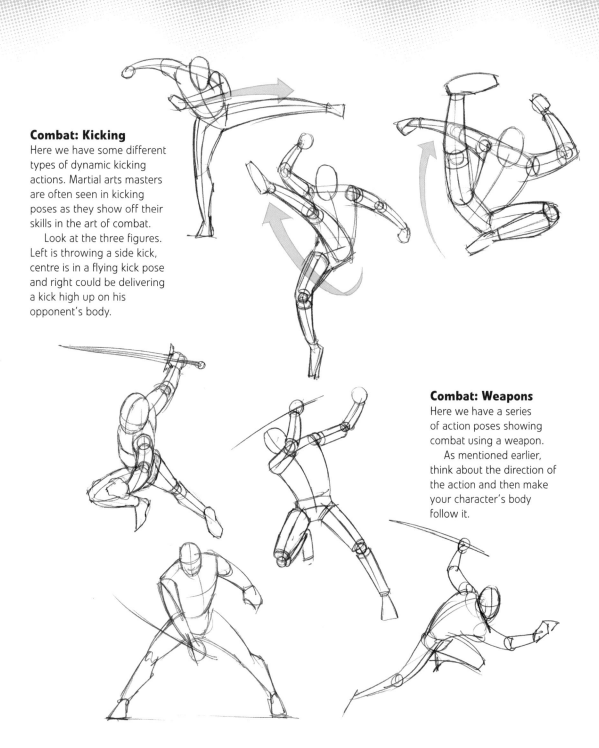

Combat: Kicking

Here we have some different types of dynamic kicking actions. Martial arts masters are often seen in kicking poses as they show off their skills in the art of combat.

Look at the three figures. Left is throwing a side kick, centre is in a flying kick pose and right could be delivering a kick high up on his opponent's body.

Combat: Weapons

Here we have a series of action poses showing combat using a weapon.

As mentioned earlier, think about the direction of the action and then make your character's body follow it.

PRACTICE COMBAT

Use these pages to practice drawing a range of combat poses.

PRACTICE COMBAT

ACTION GALLERY

In comic strips and graphic novels, your heroes can go way beyond the normal confines of human movement. They not only run at high speed, they are also able to jump to great heights, and even fly through the air. Work out how to show the different types of movement.

Here are some more examples of exciting action poses for you to practice. Try following them through to a final stage drawing.

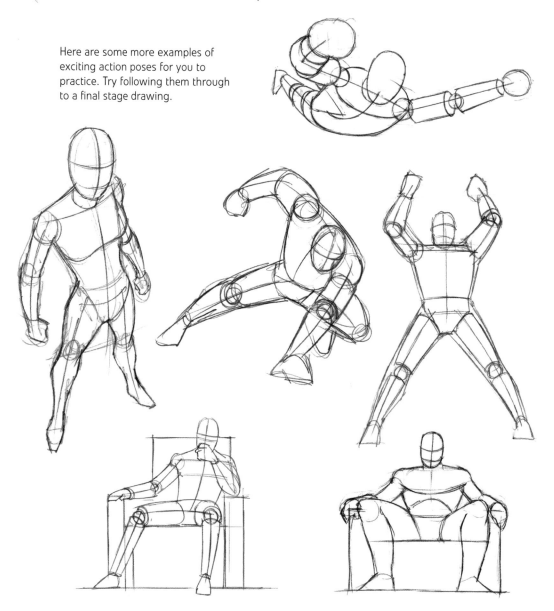

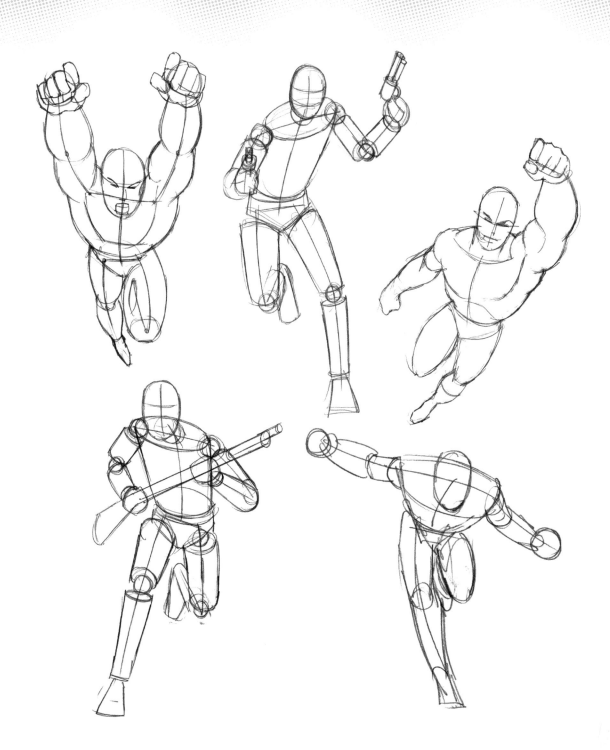

PRACTICE ACTION GALLERY

Use these pages to practice all kinds of action, from running to flying through the air.

PRACTICE

ACTION GALLERY

EASY STEPS TO ACTION POSES

The following pages show two examples of dynamic poses broken down into five easy-to-follow stages.

Example 1: Superhero
Here's how to draw our superhero leaping into action! Note—you can see this character in colour on page 16.

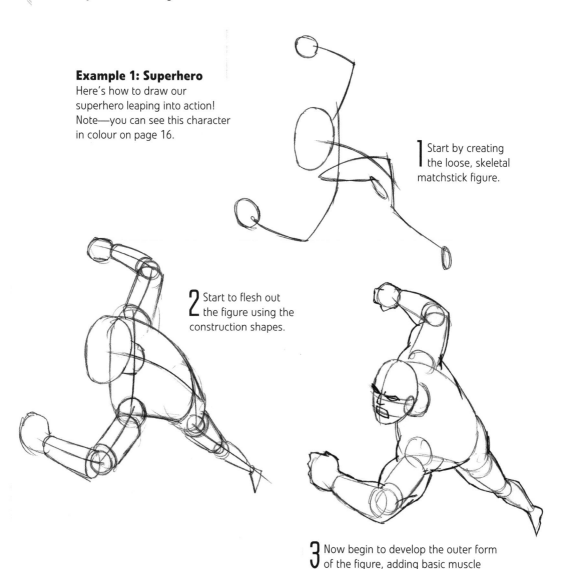

1 Start by creating the loose, skeletal matchstick figure.

2 Start to flesh out the figure using the construction shapes.

3 Now begin to develop the outer form of the figure, adding basic muscle detail. At this stage you should keep your pencil sketch loose and light.

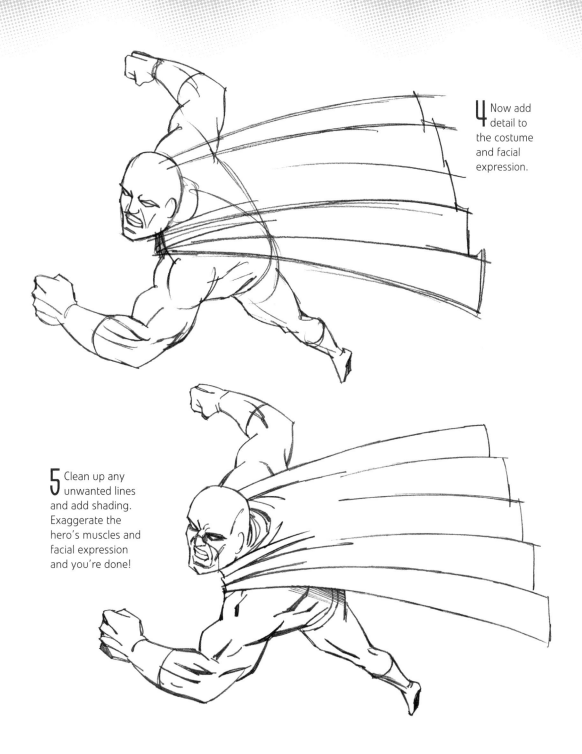

4 Now add detail to the costume and facial expression.

5 Clean up any unwanted lines and add shading. Exaggerate the hero's muscles and facial expression and you're done!

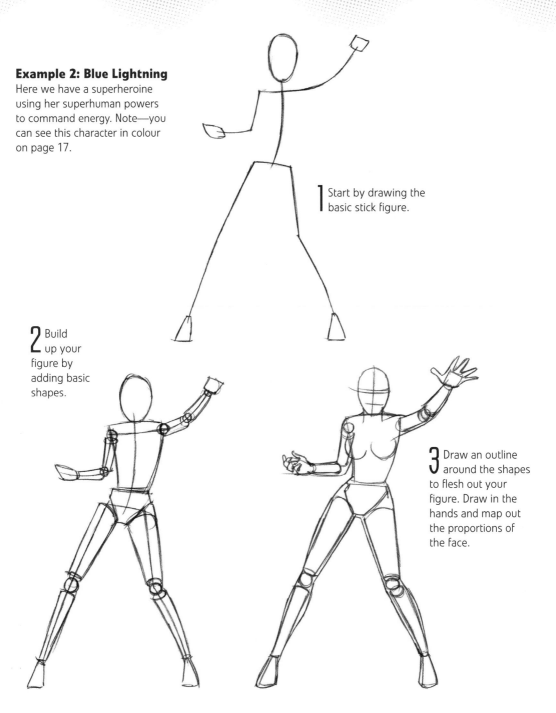

Example 2: Blue Lightning
Here we have a superheroine using her superhuman powers to command energy. Note—you can see this character in colour on page 17.

1 Start by drawing the basic stick figure.

2 Build up your figure by adding basic shapes.

3 Draw an outline around the shapes to flesh out your figure. Draw in the hands and map out the proportions of the face.

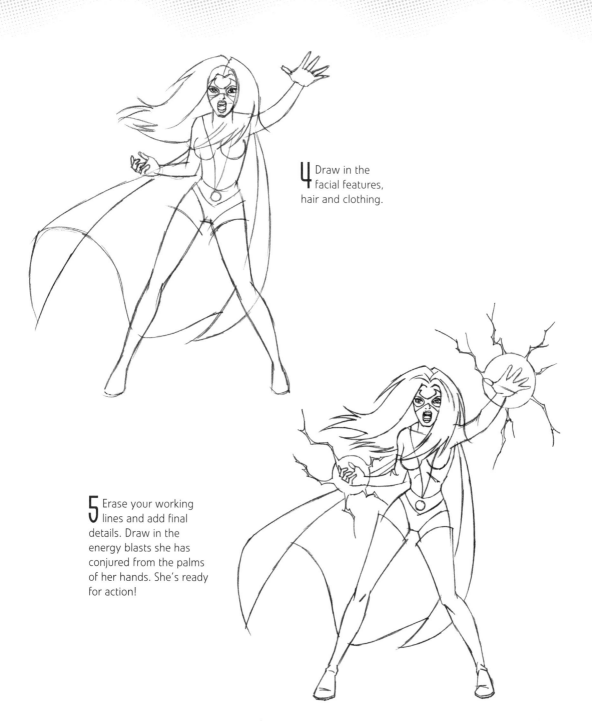

4 Draw in the facial features, hair and clothing.

5 Erase your working lines and add final details. Draw in the energy blasts she has conjured from the palms of her hands. She's ready for action!

PRACTICE

Use these pages to create your own action
heroes and their special characteristics.

PRACTICE

MAKING A STORY

If you're brimming with ideas, you can rush straight in and draw your story onto paper right away. But, for most creators, a good page of graphic art requires a bit of preparation.

1 The script

First write your story, with notes on the action that will take place on each page. The characters who appear in the adventure will need to be thought out. What do they look like, what do they wear, and how do they behave?

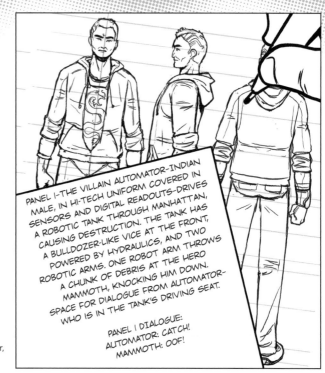

PANEL 1—THE VILLAIN AUTOMATOR—INDIAN MALE, IN HI-TECH UNIFORM COVERED IN SENSORS AND DIGITAL READOUTS—DRIVES A ROBOTIC TANK THROUGH MANHATTAN, CAUSING DESTRUCTION. THE TANK HAS A BULLDOZER-LIKE VICE AT THE FRONT, POWERED BY HYDRAULICS, AND TWO ROBOTIC ARMS. ONE ROBOT ARM THROWS A CHUNK OF DEBRIS AT THE HERO MAMMOTH, KNOCKING HIM DOWN. SPACE FOR DIALOGUE FROM AUTOMATOR—WHO IS IN THE TANK'S DRIVING SEAT.

PANEL 1 DIALOGUE:
AUTOMATOR: CATCH!
MAMMOTH: OOF!

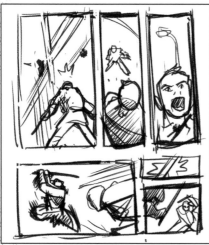

2 Thumbnails

Now the page can be mapped out. These first small, rough sketches for page layouts are called **thumbnails**. When you're happy with the layout, you can move to a larger sheet of paper and prepare for the finished artwork.

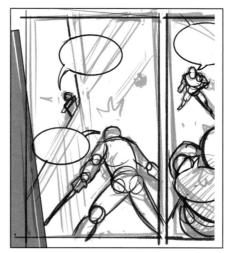

3 The panels

The panels are lightly ruled on the page and the positions for **speech balloons** marked out. The penciling for each panel begins. You can start wherever you like on the page.

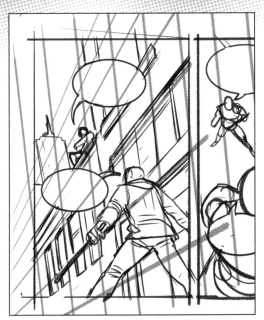

4 Perspective

Guidelines for **perspective** help create a 3D environment for many scenes. You can start drawing your characters as stick figures so that you get their pose and position right.

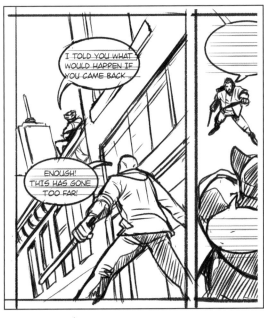

5 Pencils

The final pencil sketches are drawn. Ruled lines are added to the speech balloons and the dialogue is written to make sure enough space is left for it.

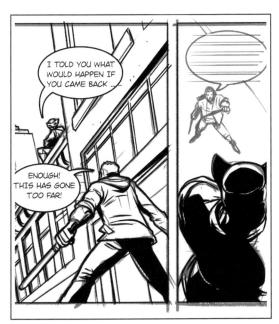

6 The panels

The pencils are inked with a pen or brush, including the outlines for the panels and speech balloons. Once the ink is dry, the pencil lines can be erased. Finally, it's time for the colors ... and the job is done!

SOURCE MATERIAL

Using models and picture reference for your drawing isn't cheating. By referring to real life, you'll improve your skills and build up an image bank in your head.

You can learn a lot from studying comics and graphic novels, but it's no substitute for drawing from real life. Ask friends and family to pose for you.

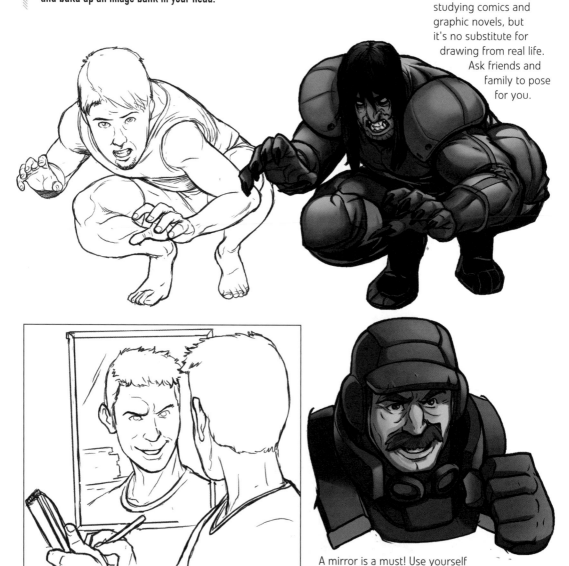

A mirror is a must! Use yourself as a model to capture tricky facial expressions, hand gestures and poses.

Keep clippings of useful magazine photos of athletes, fashion, vehicles and buildings, or search online for reference pictures. But, while using picture references can improve the realism in your drawing, don't let it stop you from using your imagination!

DRAWING A DYNAMIC PAGE

Not all comic books and graphic novels have to include over-the-top action. Some have a more realistic feel to them, for instance, a crime comic, or a human interest story where dynamic action poses may not be required. However, for a book page to look exciting, the panels must instantly grab the reader's attention. This can be achieved by adjusting the angle (point of view) of the panel scene. Some panels may have little or no action in them, so the panels that show the exciting bits of the story need to be used to maximum advantage!

Study the two examples of different pages that follow here. They both tell exactly the same story, but are drawn using different points of view. The panels show a superhero flying through the sky over a city. Suddenly there is an explosion below in a building. The hero flies towards the scene of destruction in the hope that he can save lives! Notice how, by adjusting the angle, you can maximize the impact of your panels.

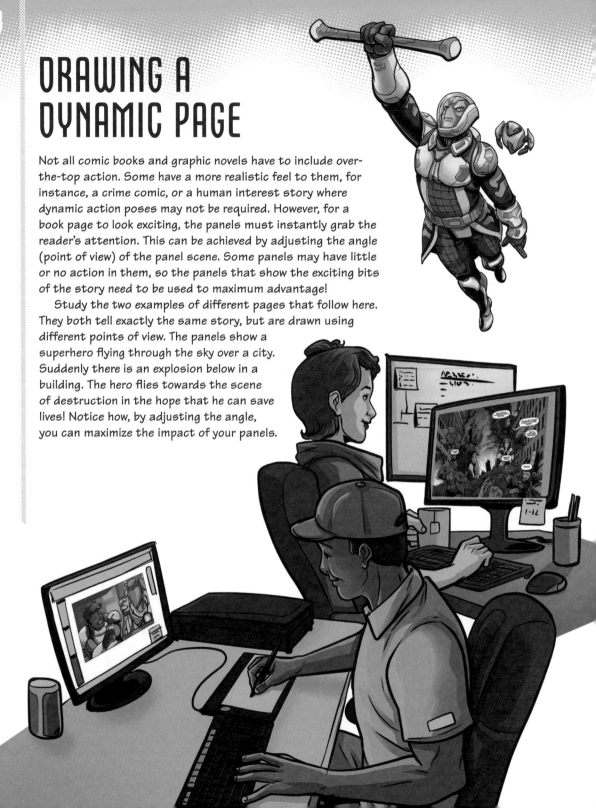

Example 1

Okay, here's how not to do it! In example 1, all the panels have been drawn using a very dull point of view. The viewpoint is at eye-level on every panel. Keeping the same point of view for each panel restricts the amount of information you can include and can spoil the flow of your storytelling.

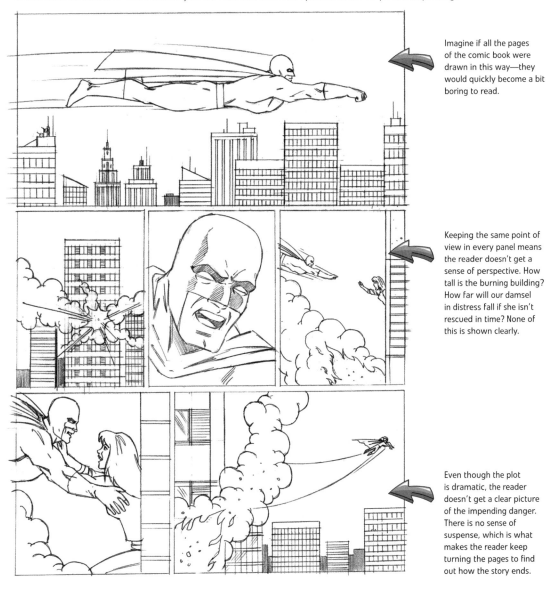

Imagine if all the pages of the comic book were drawn in this way—they would quickly become a bit boring to read.

Keeping the same point of view in every panel means the reader doesn't get a sense of perspective. How tall is the burning building? How far will our damsel in distress fall if she isn't rescued in time? None of this is shown clearly.

Even though the plot is dramatic, the reader doesn't get a clear picture of the impending danger. There is no sense of suspense, which is what makes the reader keep turning the pages to find out how the story ends.

Example 2
Wow—what a difference!

Here, the point of view in each panel is used to set the pace and flow of the story. This gives a much more exciting view of the action, drawing in and keeping the reader hooked from one panel to the next.

This time the hero has a dynamic pose and we view him flying above the city from a more interesting angle.

Here, we view the explosion from below, keeping the hero in frame so we know he is nearby.

In the next panel, the angle switches to show the hero surveying the scene from above. He has spotted a figure in need of rescue in the burning building.

Now we get a straight-on view at a high level. This shows the reader that our damsel in distress is dangerously high up in the building!

Here we have the hero rescuing the girl from a more exciting viewpoint.

The final panel shows the action from below and we see the girl safe in the arms of the hero. He carries her up and away from the building just as there is another big explosion!

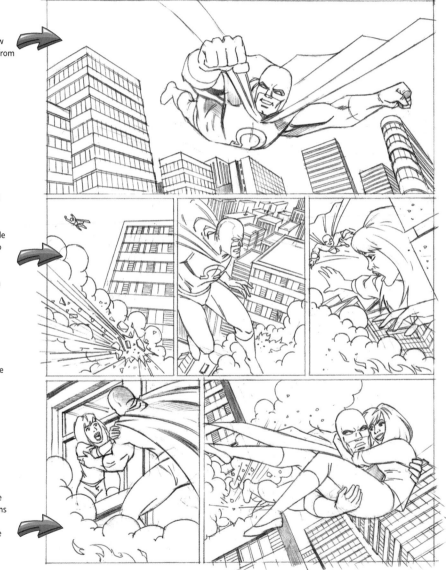

Which of the two versions of this story do you find the most interesting to look at? If you find the panels in example 1 a little boring, it's likely that a reader would also be bored if you drew your comic book in this way.

PRACTICE

Use this page to plan some storyboards for
your graphic novel story.

PAGE CREATION

Before you learn the step-by-step process of pencilling a comic book page, it's a good idea to familiarize yourself with the various elements that can be used to create one. Once you have learnt how these all work together, you'll have all the tools you need to create your own fantastic comic book pages!

Splash page

There are two different types of page in a comic book or graphic novel: a splash page (right) and a standard page (far right). A splash page is often used on the first page to establish the main character, set the scene and act as an introduction to the story.

A splash page always features a full-page drawing with no additional story panels. It has to look dramatic and exciting to catch the attention, and encourage the reader to delve into the rest of the story.

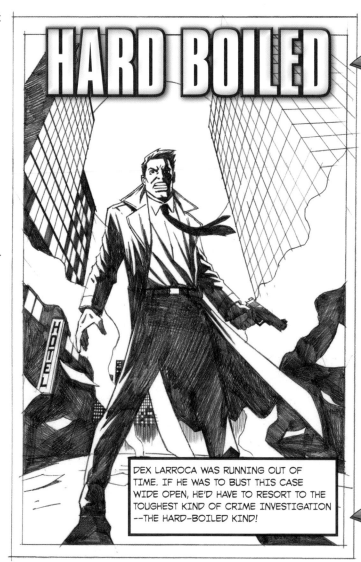

The title of the story appears in huge type, as a banner heading. Letters drawn in outline like this are called "open letters". They're left un-inked so that color can be added later.

Text that talks directly to the reader, rather than appearing in a speech bubble, is called a caption.

Standard page

Here is a standard comic book page. The action has been divided up into panels.

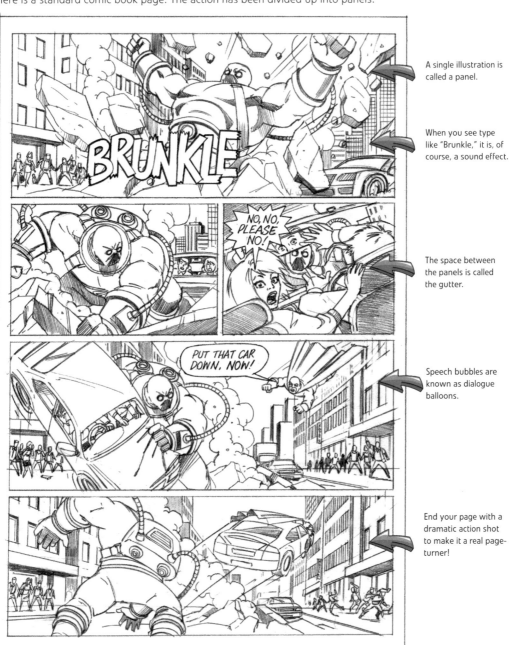

A single illustration is called a panel.

When you see type like "Brunkle," it is, of course, a sound effect.

The space between the panels is called the gutter.

Speech bubbles are known as dialogue balloons.

End your page with a dramatic action shot to make it a real page-turner!

PRACTICE

Use this page to create a splash page to
introduce your main character.

PRACTICE

Use this page to create a series of panels to move the story on.

TYPES OF PANELS

In many ways, planning a comic book is similar to movie making. Even though the action in a comic book is static, you still need to consider the best angle to use for each panel. Similarly, a movie director chooses the position from which his camera will get the most effective shot. Certain angles are more exciting than others and it's up to you to find the ones that will illustrate the plot clearly, while keeping the reader interested. Let's take a closer look at different types of panel, what they are called and why they are used.

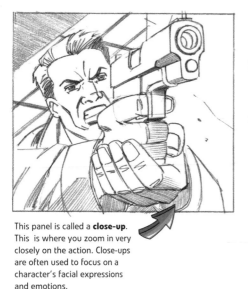

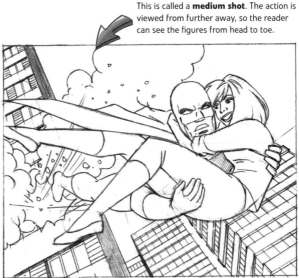

This is called a **medium shot**. The action is viewed from further away, so the reader can see the figures from head to toe.

This panel is called a **close-up**. This is where you zoom in very closely on the action. Close-ups are often used to focus on a character's facial expressions and emotions.

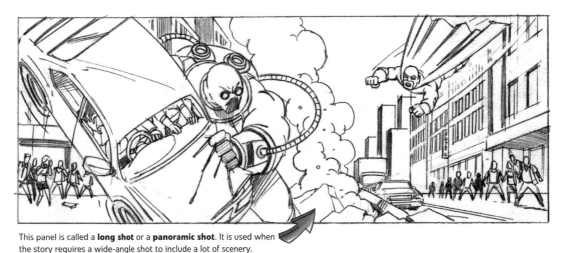

This panel is called a **long shot** or a **panoramic shot**. It is used when the story requires a wide-angle shot to include a lot of scenery.

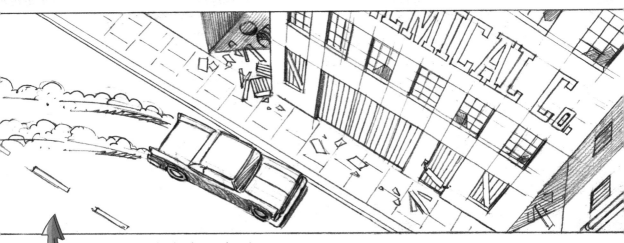

Here is another long shot, but this time the action is seen from above as a "bird's eye view".

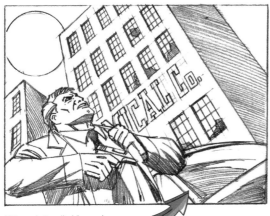

This angle is called "worm's eye view". It shows the action from below.

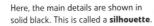

Here, the main details are shown in solid black. This is called a **silhouette**.

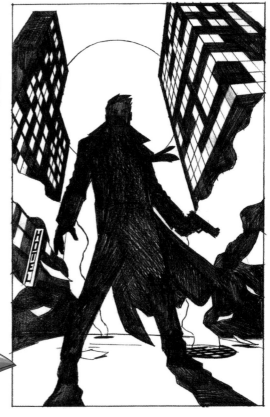

PRACTICE

Create some panels with close-up views here.

PRACTICE

Use this space for long shots and silhouettes.

STORYTELLING

Your choice of panel type affects the story, composition, and layout, and is a very important part of comic book creating. Each panel must be carefully composed so that the story is easy to follow. The action should flow from panel to panel in a way that is eye-catching.

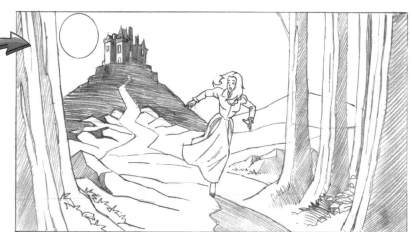

Setting the scene

This long shot has been chosen to set up the story. It leaves the reader eager to discover what will happen next.

Readers in the West normally scan a page from left to right and top to bottom. Notice how the elements in this panel flow from left to right. This is the order in which they will be viewed.

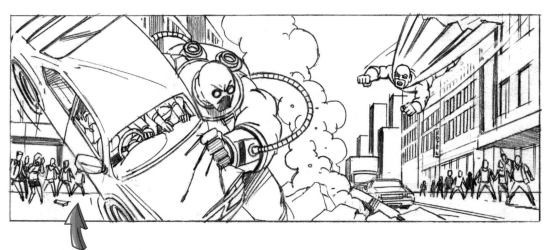

Packing in information

This wide-angle shot is bursting with action and information. All the elements work logically so that the reader can immediately understand the story. A graphic novel page should be drawn so that it all makes sense without the aid of captions or dialogue balloons.

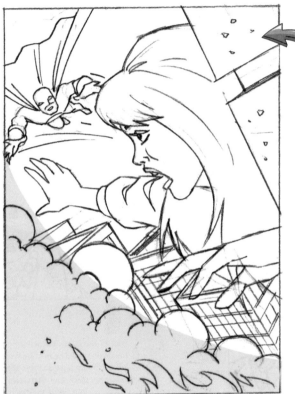

Framing the action

Here is a close-up shot. It's an intense scene in which the hero is rushing to save a woman who is trapped in a burning building. Notice how the main interest is grouped in the top half of the frame. The smoke, below, is used to frame the action.

Dramatic shapes

Here is another wide shot. Notice how the position of the woman's body forms a triangle. The forest makes a curve around her.

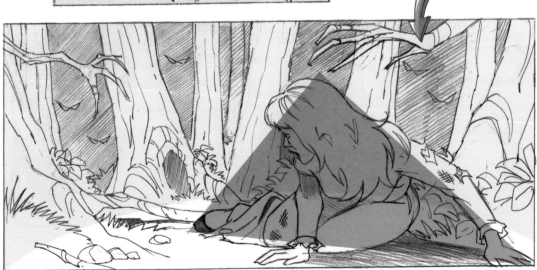

SPEAK OUT!

So far, your urban heroes have been the strong and silent types. With some well-chosen words, you can make the action and words leap off the page.

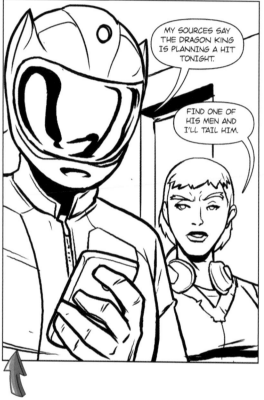

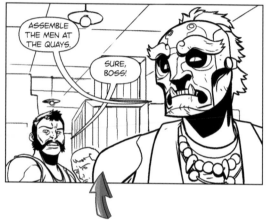

Spoken words, like the action on the page, should be read from top left to bottom right, so think ahead when you place your characters in a panel. Don't have their word balloons crossing! Above is an example of what NOT to do.

Comic books use word balloons to hold dialogue. Though you can vary the shapes, balloons tend to be oval, with a tail from the balloon pointing towards, but not touching, the mouth of the speaker. Words are usually in capital letters.

Be sure to allow enough room for the talking. Try not to cover up the characters with word balloons!

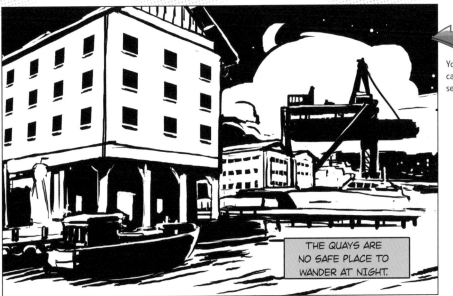

You can add a caption in a box to set a scene.

THE QUAYS ARE NO SAFE PLACE TO WANDER AT NIGHT.

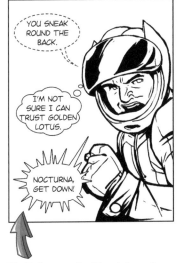

YOU SNEAK ROUND THE BACK.

I'M NOT SURE I CAN TRUST GOLDEN LOTUS.

NOCTURNA, GET DOWN!

HERE COMES SALAMANDER! LAY LOW! HE WON'T SUSPECT A THING!

YOU EXPECTING SOMEONE **ELSE**? THE SURPRISE IS ON **YOU!**

Word balloons can be different shapes for different expressions:
• A dashed border for whispers.
• A cloud shape for thoughts.
• A starburst for shouts or screams.

When writing speech, use lightly ruled lines with some space between them. Write in the dialogue, then use an ellipse template or curve tool, if you have one, to draw the balloon border.

Write in neat capitals and leave a border around the words inside the balloon. A technical pen is good for this. You can use a thicker pen to write bolder words for emphasis.

Finally, remember that comics are a visual medium. While words matter, don't forget to show your characters expressing themselves with their actions, too!

INKING AND COLORING

There are a number of ways to ink your pencil drawing. Some artists prefer to use a brush and a pot of black Indian ink. We recommend that you use watertight Indian ink to ink your pencil drawings, so that when you apply your color on top, your ink will not raise or smudge. If you decide to use a brush, a #3 sable brush can be used to achieve a variety of line thicknesses.

There are also lots of good inking pens available, with a range of nib thicknesses, including "superfine", "fine" and "brush". The "brush" nib pens are very good as they produce a good range of line thicknesses too (see right).

Once you have inked your drawing, it's time to move on to the coloring. On the following pages we'll show you how to build up layers of color on top of your inked drawing. The key is to start by applying lighter colors as your base, then building up the color by adding layers of darker tones over the top.

Example: Martial artist
A clean, crisp line style has been used to ink this character, but you may wish to experiment with different styles and textures of your own. Color has been applied in layers for a rich, tonal finish.

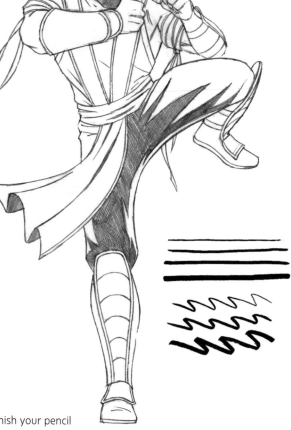

1 Finish your pencil drawing, marking out any areas of shading to go over in solid, black ink.

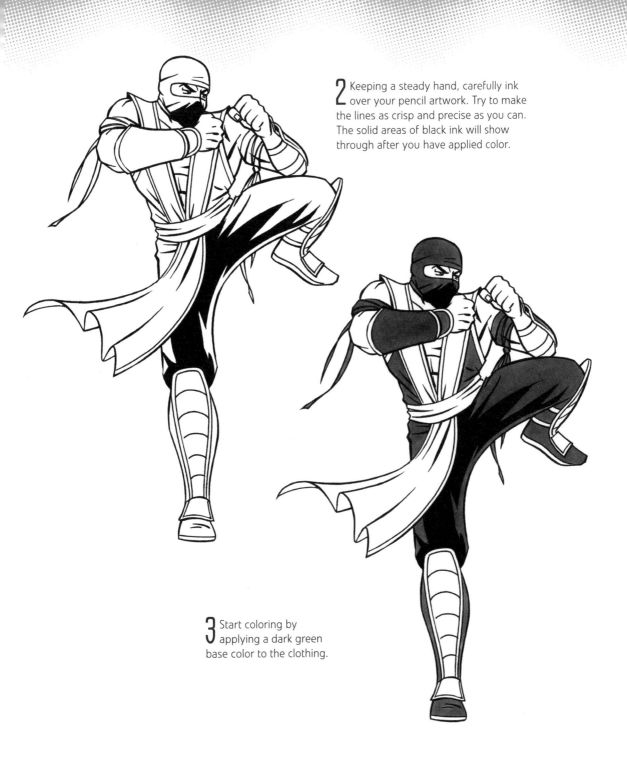

2 Keeping a steady hand, carefully ink over your pencil artwork. Try to make the lines as crisp and precise as you can. The solid areas of black ink will show through after you have applied color.

3 Start coloring by applying a dark green base color to the clothing.

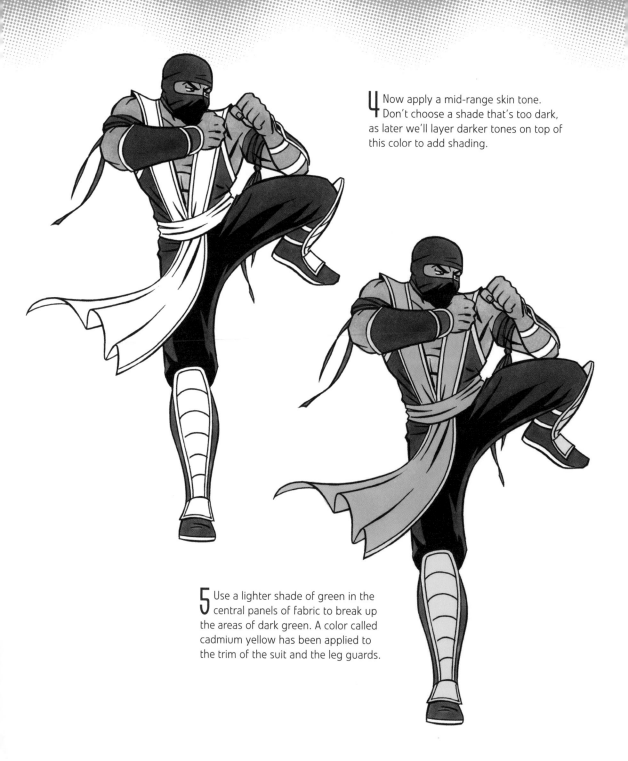

4 Now apply a mid-range skin tone. Don't choose a shade that's too dark, as later we'll layer darker tones on top of this color to add shading.

5 Use a lighter shade of green in the central panels of fabric to break up the areas of dark green. A color called cadmium yellow has been applied to the trim of the suit and the leg guards.

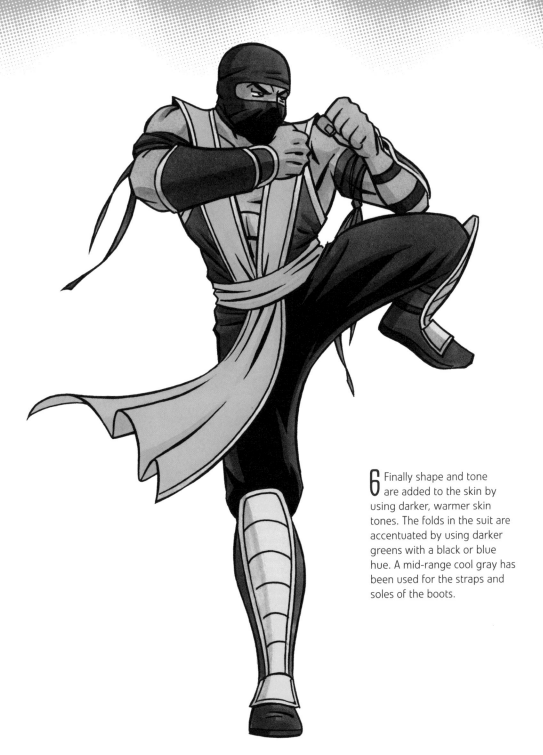

6 Finally shape and tone are added to the skin by using darker, warmer skin tones. The folds in the suit are accentuated by using darker greens with a black or blue hue. A mid-range cool gray has been used for the straps and soles of the boots.

INKING AND COLORING A STORY

Now that you've learnt how to ink and color your character drawings, how about tackling a full page of comic book art? It's really not that difficult and the same principles apply. Here we have a page of comic book art in pencil. The solid areas of shading are marked in at the pencil stage, so it's just a case of inking faithfully over the pencil lines.

Inking and coloring a comic book page

This artwork would work equally well with even more inked shading. This would create a stronger contrast between the light and dark areas, but it would leave less room for color.

As you follow the step-by-step sequence you'll see how the areas of ink and color work together in the panels, just as they do when you're coloring an individual figure.

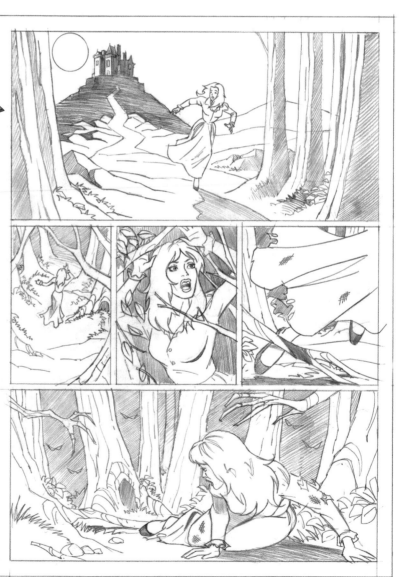

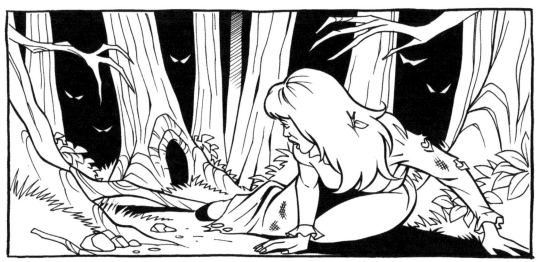

Inking styles for panels

Some artists like to ink the panel outlines freehand, without the aid of a ruler. This creates a nice contrast between the panel edge and the clean, crisp lines within the panel (above). You can also use a loose line style inside the panel for a slightly sketchier finish (below).

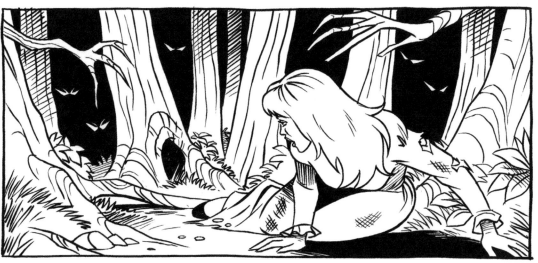

Inked page

So here it is—our fully inked comic book page. When you're creating your own comic book art, you could just choose to keep things simple and leave your artwork in black and white, but the addition of color will really bring your comic book pages to life, as you'll see on the following page!

You can see we have kept the line style clean and precise throughout.

Very little shading has been added, so that we have plenty of space left in which to apply color.

The solid areas of black create dramatic blocks of dark shading. We will also use layers of color to determine areas of light and shade in the final version.

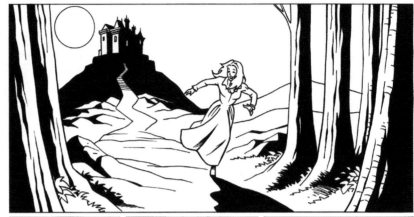

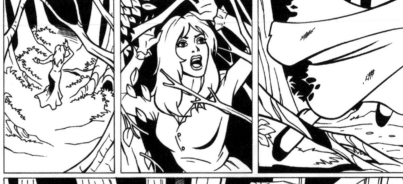

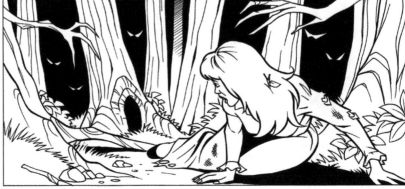

Color page

When coloring your comic book page, choose colors that help show what time of day it is. This story is set a night and the light source is the moon. To achieve a moonlit effect, use light blue as your base color on all panels.

In panel 1 we establish that the light source is the moon. On top of the light blue, layers of olive green and cool gray are applied to color the trees.

Pale blue, olive and gray are also used for panels 2, 3, and 4. The girl's skin tone and hair are colored brightly, making her the focal point. Cool gray is used to add shading to her skin, hair, and dress.

In the final panel notice how we have allowed moonlit areas of pale blue to show through on the trees and grass, keeping our light source consistent. The disembodied eyes in the forest are left in white.

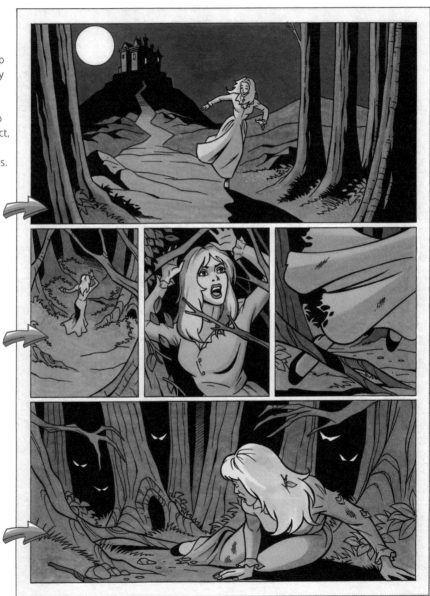

Ready to ink and color your own fantastic comic book art? We used markers to color the page above, but a similar effect could be achieved using watercolors or liquid inks. Plan your color palette before you start to apply any color, and keep it simple!

DIFFERENT KINDS OF STORIES

THE PLOT—A huge monster is rampaging through the centre of a big city. The creature lifts a car, terrifying its passengers. Just at this moment, our hero, Omegaman, arrives at the scene and The monster attacks!

Step 1: First draft

A first draft is all about figuring out how the action will flow from panel to panel. The figures are drawn very roughly, first in stick figure form then with simple construction shapes.

Perspective

Draw perspective lines so you get the angle of the buildings right, and sketch a rough grid to help you scale the foreground and background objects correctly in relation to one another.

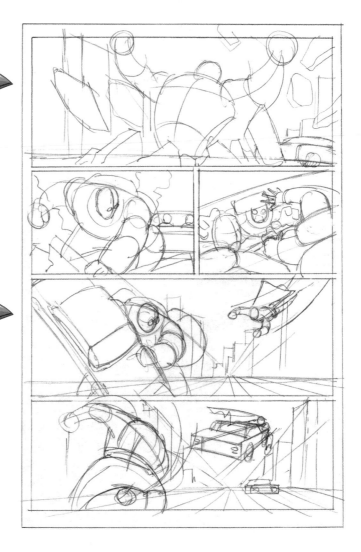

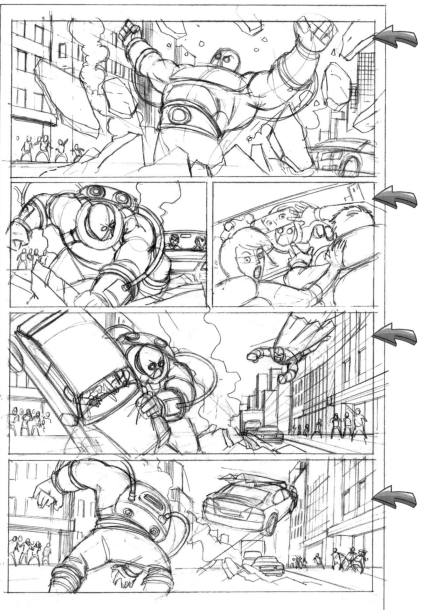

Step 2: Adding detail

Start to flesh out your figures and add detail. This page is packed with action, so keep your figures looking dynamic.

Buildings

Using the perspective lines that you drew at the first draft stage, map out the shapes of the buildings and their various heights. Take care to draw the windows of each building accurately.

Cars

Base the cars on real vehicles. You could look at some parked cars in your street or neighbourhood and do some sketches. If you base your content on real objects and pay attention to detail, your drawings will look much more realistic and polished.

Don't rush!

The more time you spend getting all the little details right at this stage, the more believable your final page will look.

Step 3:
The final
penciled page

Look at the finished page opposite. As you can see, we haven't included any text in this pencil page. This is to demonstrate how, when drawn correctly, a series of panels can clearly tell a story without any dialogue. The guide below gives a description of each panel.

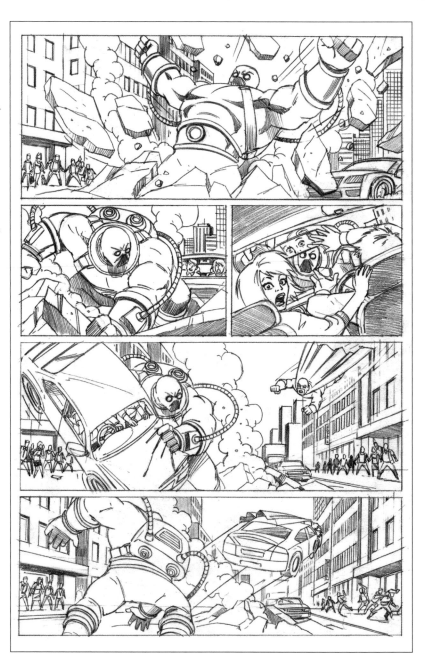

Panel 1

This shows the entrance of the crazy monster as it smashes up through the road, scattering debris everywhere. We also see a car screeching to a halt on the far right. This is the reader's first sight of the monster's victims.

Panel 3

We now switch to a point of view inside the car, as the monster approaches and grabs the bonnet.

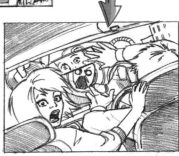

Panel 2

Next, the monster climbs out of the hole in the ground and notices the car and its passengers.

Panel 4

A wide shot shows both the monster and the hero rushing to the rescue. The monster turns its back away from the hero, holding the car like a weapon...

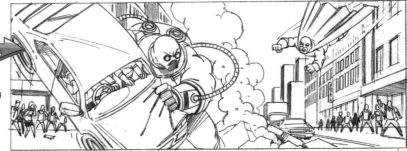

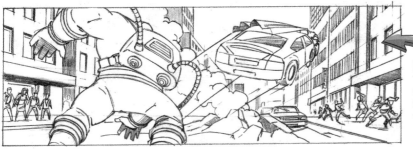

Panel 5

The monster hurls the car with the passengers still inside at Omegaman. But what happens next?

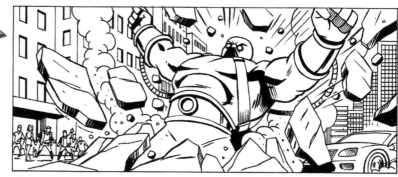

Step 4: Inking
Take time to carefully ink over the pencil drawing.

Inking tools
A technical inking pen has been used for the straight lines. A brush ink pen has been used for the linework in the foreground.

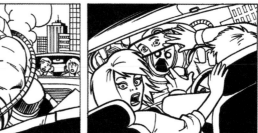

Types of lines
Different line widths can make objects look distant or close. Use light, thin linework for objects in the background. Use bolder linework for the objects in the foreground so that they stand out.
This will make the drawing look less flat.

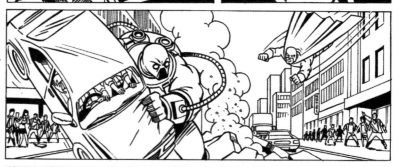

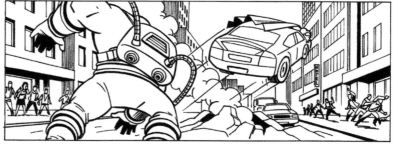

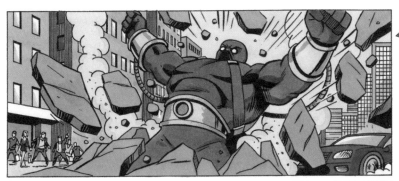

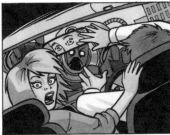

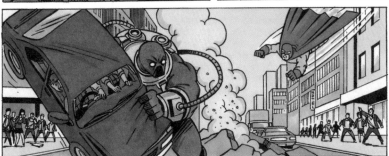

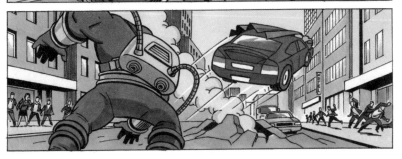

Step 5: Coloring

This scene is set in the daytime, so a pale blue sky has been used in all panels. The buildings are a mixture of off-white, sand, beige, and pale grays. A cool gray has been used for the road and scarlet for the car.

Heroic hues

The colors we have chosen for the superhero are sky blue for the mask and cape, and pale blue for the body.

Sinister shades

The villain's costume has been colored using a light blue overlaid with gray. The metallic parts of the suit have been colored cadmium yellow. A cool gray has been chosen for the boots.

PRACTICE

Use these pages to create a fully-inked version of
a story with a monster at its heart.

PRACTICE

A HORROR STORY

THE PLOT—A group of friends have gathered in an old gothic mansion, secluded deep in a valley. A series of strange noises and unexplained movements haunts their stay, culminating in the arrival of a terrifying vampire-like creature.

Step 1

Decide what your story is and how many frames you need to tell it. Then create a rough sketch of the page. Don't try to fit too much into each frame. In our first panel, the scene is set with a mystery character at the foot of a creepy staircase. In the second and third panels, they approach a door and open it to reveal what's inside. Then the main action happens in the final panel, when the character is revealed as a monster!

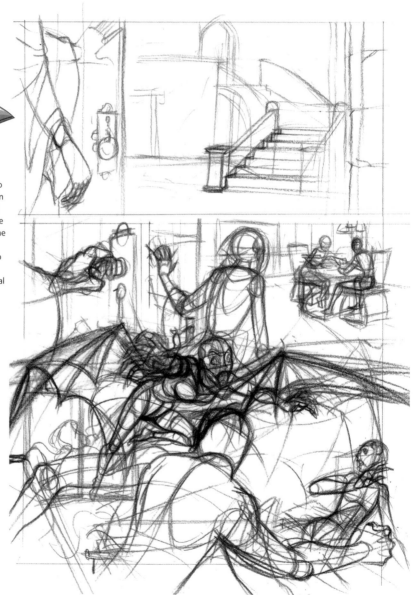

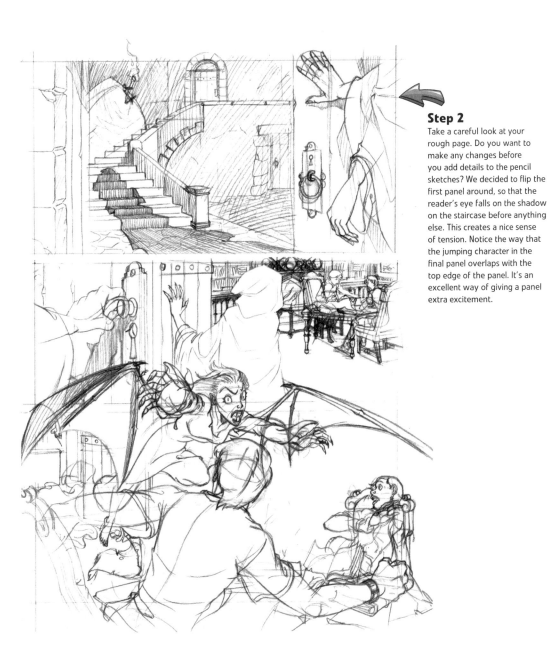

Step 2

Take a careful look at your rough page. Do you want to make any changes before you add details to the pencil sketches? We decided to flip the first panel around, so that the reader's eye falls on the shadow on the staircase before anything else. This creates a nice sense of tension. Notice the way that the jumping character in the final panel overlaps with the top edge of the panel. It's an excellent way of giving a panel extra excitement.

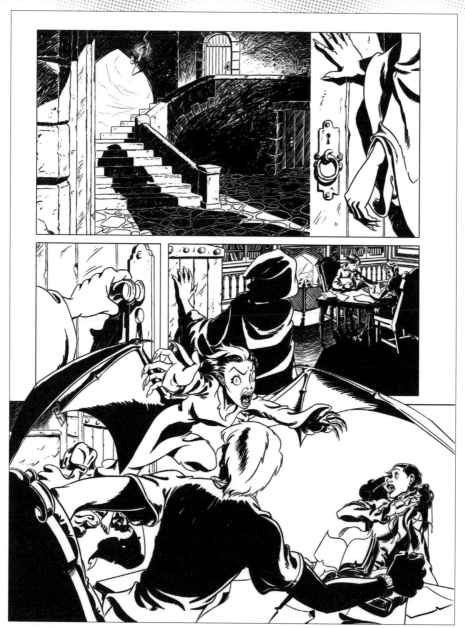

Step 3

We've really gone to town with the shadows at the inking stage. By using plenty of black, you can show readers that this is a chilling tale and put them on edge. Notice that we have not lost any detail, though, because we have used narrow white lines to show shapes and textures within the shadowy areas.

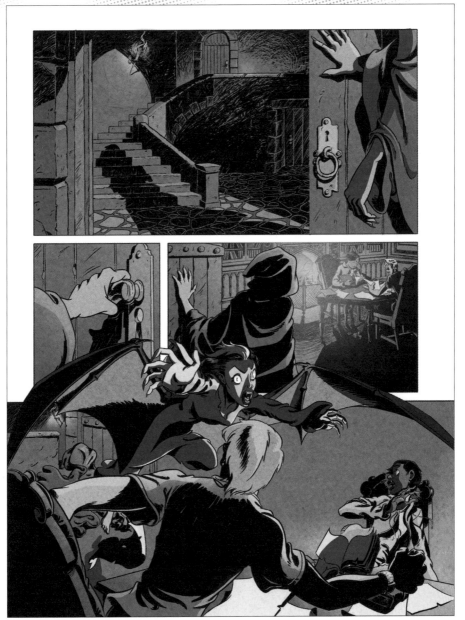

Step 4

The color version of this story cleverly uses light and shade, too. Your eye seeks the detail in the top scene, and then it is drawn to the light farther down. Clever details, such as the yellow keyhole in frame two, link the panels together and give visual clues to what is happening and where the action is taking place.

PRACTICE

Use these pages to create a fully-inked version of
a horror story.

PRACTICE

A CRIME STORY

THE PLOT—Hard-boiled cop Dex Larroca is hoping to arrest a dangerous criminal. He follows a lead to an abandoned warehouse and breaks in to search the building.

Step 1: First draft
Rough out the story in the panels using simple shapes to establish the composition and content of each one.

Consider the different types of panels and which angle will work best for each step of the action. Remember to keep it simple but exciting!

Stop every so often and take a look at the whole page. Ensure the story makes sense from panel to panel before you add any detail.

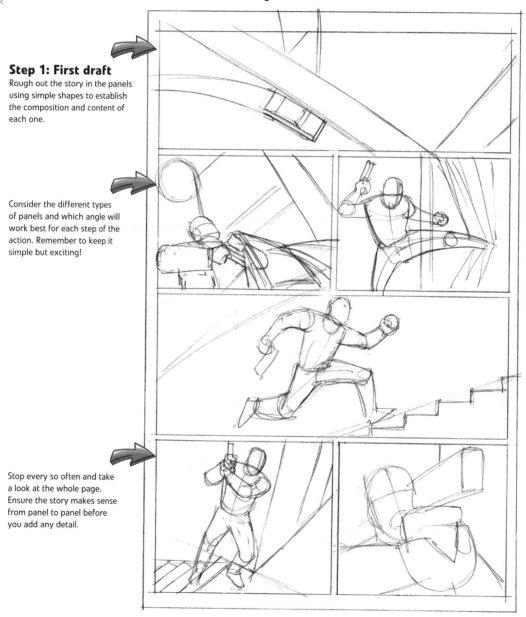

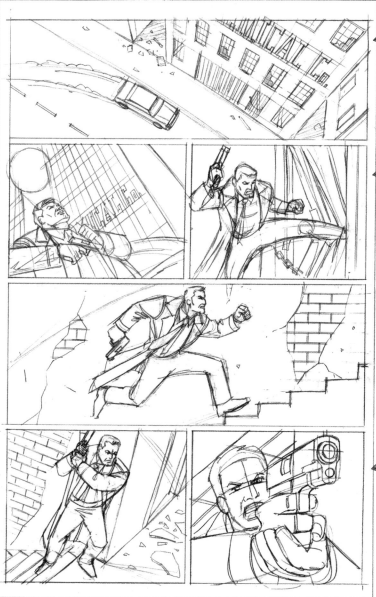

Step 2: Adding detail

Once you are happy that the series of panels works effectively, start to add more detail to your layout.

On the grid

Use grid lines to help get the perspective correct. As there need to be lots of different viewpoints and angles from panel to panel, you need to be careful to get the perspective just right on each one. Grids are also useful for accurately plotting where the windows of buildings should go.

Consistency

Try to keep the look of your character consistent from panel to panel. Do lots of sketches before you start to draw a whole page, so you know every detail of your character's appearance.

Step 3:
The final
penciled page

On the page opposite you can
see Dex Larroca in action in the
finished comic-book page. See
how shading and fine details
have been added, such as the
timberwork on the boarded-
up windows and exposed
brickwork where plaster has
broken away. The final panel
of the story leaves the reader
guessing who or what might
be waiting for Dex as he turns
the corner.

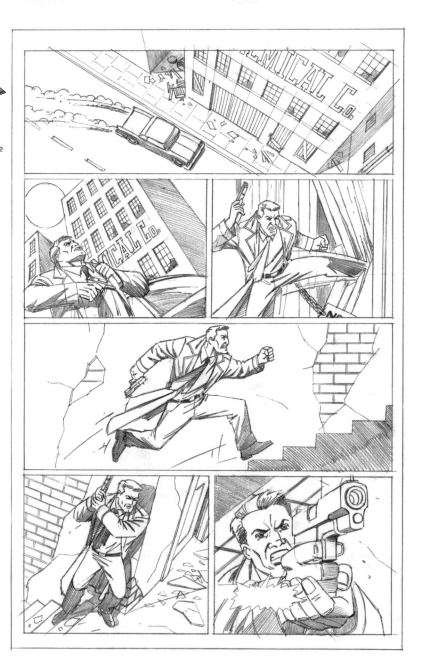

Panel 1

We open with a bird's-eye view of Dex pulling up outside the warehouse. This angle is excellent for establishing a location. It also makes the reader feel that the character is being watched.

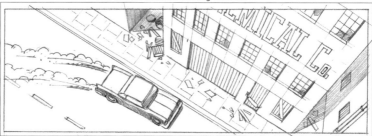

Panel 2

Here we have a worm's-eye view as Dex gets ready to enter the building.

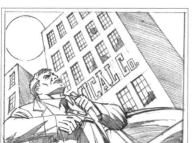

Panel 3

This is a straight-on medium shot.

Panel 4

This is a kind of wide-angle medium shot. It gives a strong sense of sideways movement.

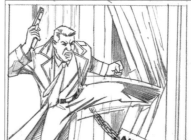

Panel 5

Again, this angle suggests that Dex may be being secretly observed by someone outside the panel. This creates extra suspense and a feeling of unease in the reader.

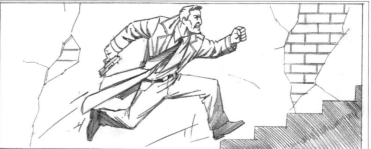

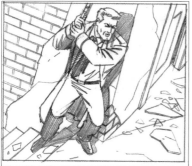

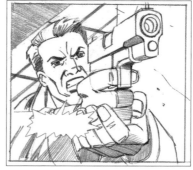

Panel 6

Finally, we cut to an intense close-up as Dex turns the corner. He shouts, 'FREEZE!'

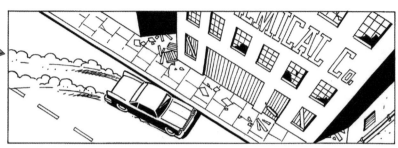

Step 4: Inking

Trace over your pencil lines, again using stronger, thicker lines for the objects in the foreground.

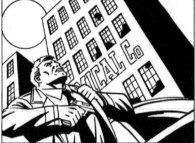

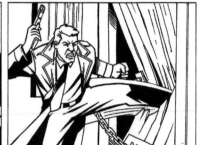

Crime noir

Notice how some areas are filled with solid black. For example, the sides of buildings, the stairs and Dex's legs and feet are filled with ink. This is not strictly realistic, but it gives a nice sense of weight and contrast to your artwork. Heavy use of solid ink blocks is especially popular in crime and horror comics.

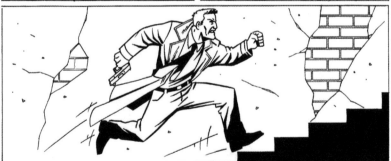

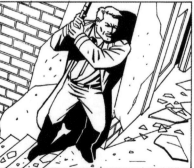

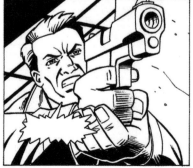

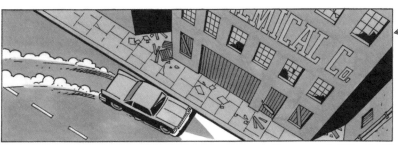

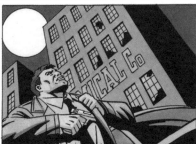

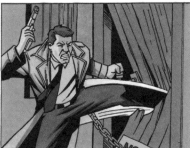

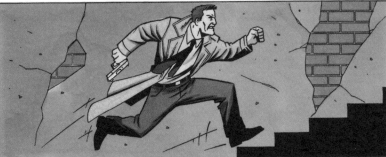

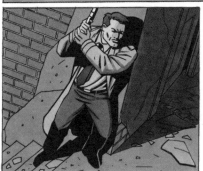

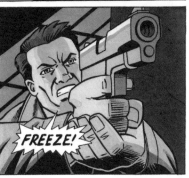

Step 5: Coloring

A different color palette is used in the first three and second three panels. This gives a different feeling to the outdoor and indoor scenes.

Outdoor colors

A base color of pale blue was applied to panels 1, 2, and 3 so that when other colors were added over the top it would give a moonlit tone to the scene.

Indoor colors

Panels 4, 5, and 6 are inside the building. Dark tones of gray were used to give the place a gritty, poorly lit feel. A very pale gray was also used as a base for the detective.

PRACTICE

Use these pages to create a fully-inked version of a crime-based story.

PRACTICE

A SCI-FI STORY

THE PLOT—Space pilots Zak and Lara return to their satellite headquarters to find that it has been infested by aliens. Not just any aliens, but the most dangerous kind of all: man-eating space apes!

Step 1: First layout

It's a good idea to experiment with different layouts. Your page must be dynamic and exciting but also easy to read.

What's wrong here?

The panels in this layout are all roughly the same size, which gives us very little space for the action. The characters are more or less viewed from the same angle and distance throughout. The layout could be much more dynamic and varied, and the final panel would work better with more room to breathe.

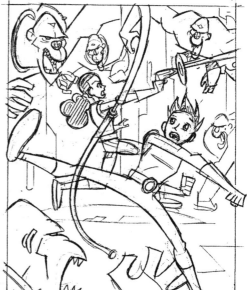

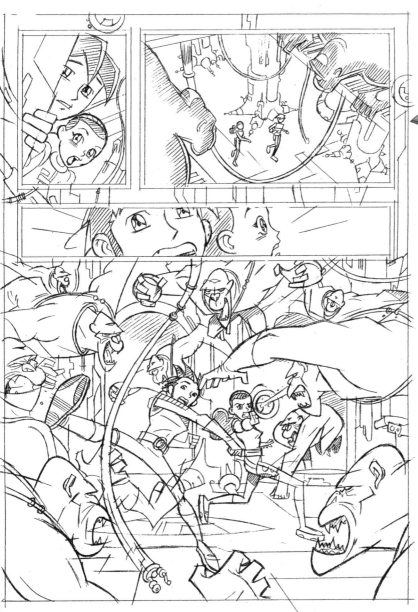

**Step 2:
Revised layout**
Now this is much better.
In these layouts we've
used a range of different
"camera" angles.
Everything leads up to
the final exciting action
panel. Best of all, this has
been achieved without
making the panel sizes
and angles confusing or
distracting. The story still
makes perfect sense.

Step 3: Inking

This page has been inked with sharp, neat lines. Heavier lines are used for the outlines of objects.

The edges of the panels have been given a very thick, stylised line. Notice how the gutters of the first three images are part of the large image below.

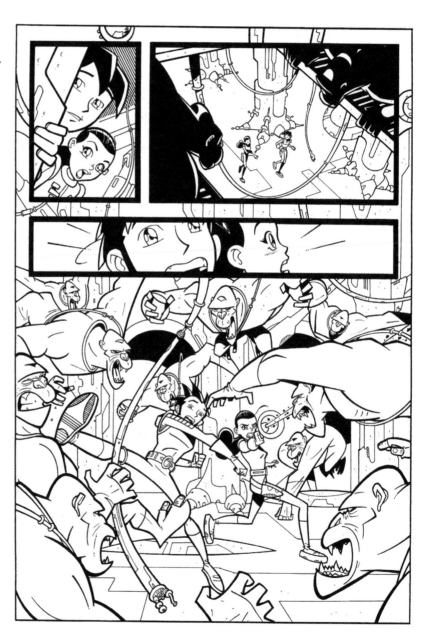

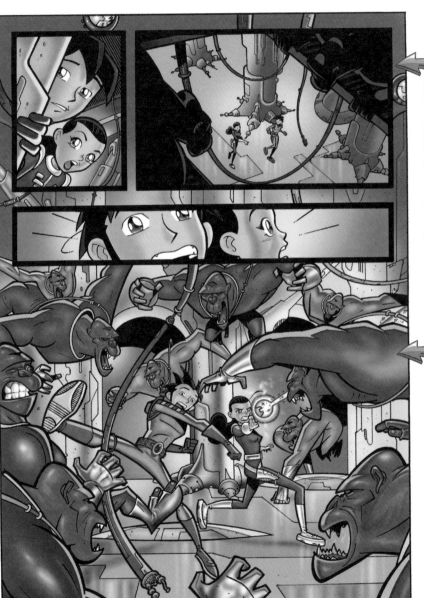

Step 4: Coloring
Here's the finished page. The main palette that we have chosen for this page is a mixture of purple and gray. Zak and Lara stand out against this background because of their contrasting red and blue costume colors.

Computer colors
Unlike the previous colored pages, which were colored in a traditional way, this page has been colored using a computer. The inked artwork was scanned into the computer, and the programme Photoshop was used for coloring.

PRACTICE

Use these pages to create a fully-inked version of
a sci-fi story.

PRACTICE

CAMERA ANGLES

There are many different ways to tell a comic story. an artist must choose the best angles and distances for each panel. In this short spooky story, we show an explorer opening a mysterious stone door, only to be greeted by a werewolf!

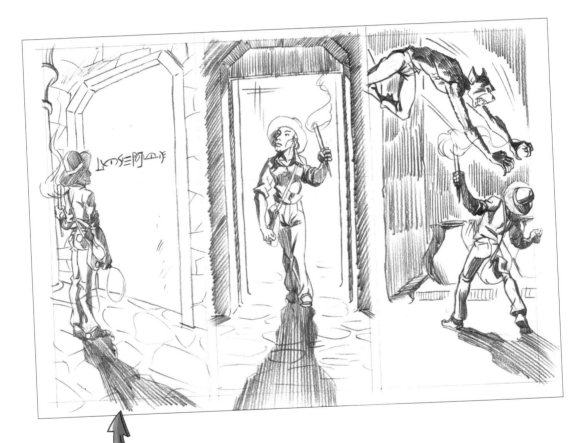

First attempt

This version of the scene isn't terrible, but it's rather static and boring. The panels are all the same size. The characters are shown from a similar distance, and the viewpoints chosen do not do enough to create a sense of urgency or drama. The reader understands the story but is not drawn in.

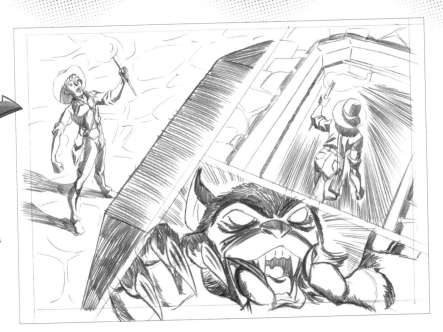

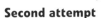

Second attempt

This second version of the scene is much more exciting. The panel shapes are interesting, and close-up shots are mixed with longer shots and varied angles. However, there is so much going on that the scene has become confused. And what is happening in the last panel? Is it even in the same place?

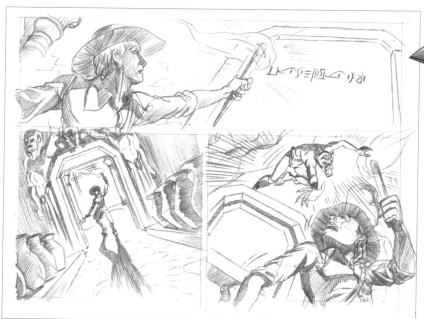

Third attempt

This third version of the scene gets the balance just right. The storytelling is nice and clear—it's not hard for the reader to tell what has happened. However, there is plenty of variation in the distance and angle from which we see the action, and there is a well-planned sense of drama and excitement.

PRACTICE

Use these pages to test out a variety of different
"camera angles" for one scene in your story.

PRACTICE

DRAWING A DYNAMIC COVER

The most important part of a comic or graphic novel is its cover. The design and artwork must grab the interest of a potential reader. We'll look at several different approaches to a front cover. The first shows an iconic hero in a dynamic pose.

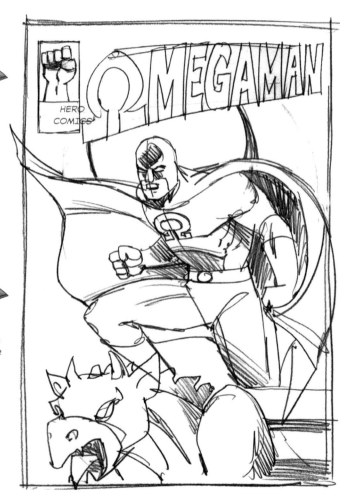

Step 1: Roughs
The first stage of the design process is the creation of thumbnail roughs. These are small, simple sketches and layouts of potential cover designs.

First rough
In this example, the hero, Omegaman, is standing on a rooftop, surveying the city. We can immediately tell he is strong, brave and ready for action. This type of cover design is often used for first issue covers.

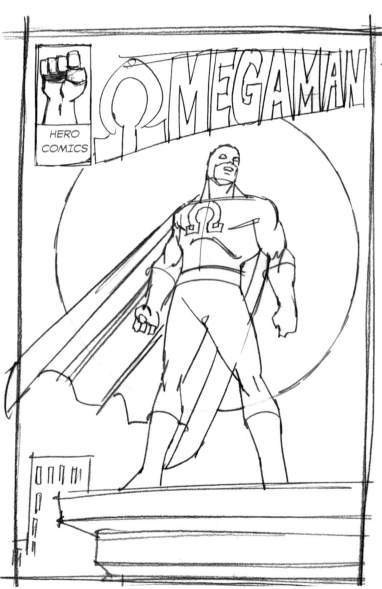

Second rough
This second attempt at a cover design shows our lead character looking nobly into the distance, with the moon looming behind him. The gargoyle has been dropped from the bottom of the image.

Step 2: Pencils

Now we need to choose the most effective elements from each rough to use on the final cover. We've chosen to keep the gargoyle from the first rough. We've taken the upright pose from the second rough, as well as the use of the moon as a framing device.

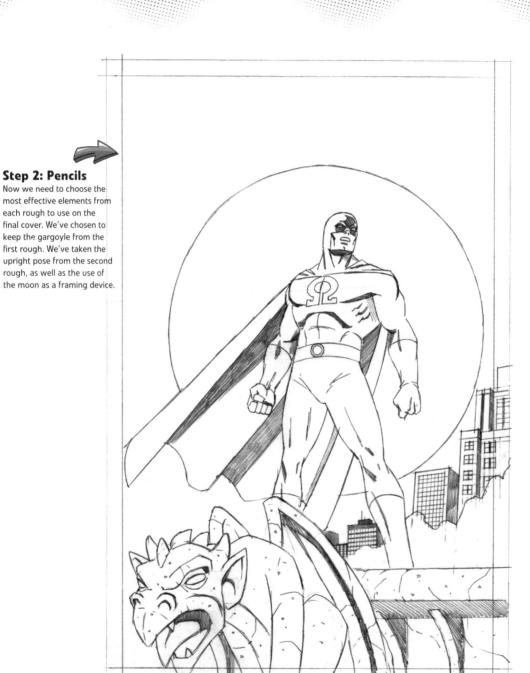

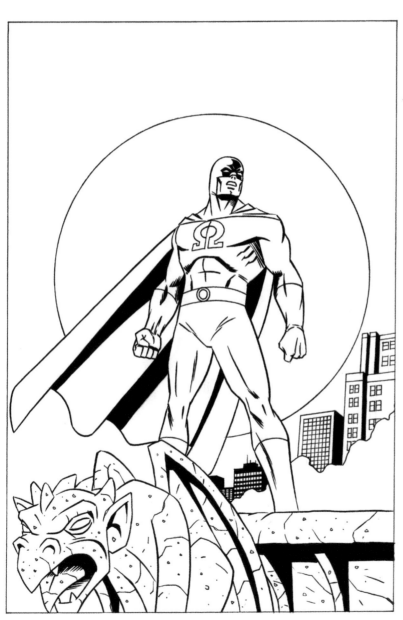

Step 3: Inks

Once the cover design has been finalized and drawn in pencil, black ink can be applied. Always remember to leave enough space in your artwork for the cover type—this is the title of your comic book and any other information you wish to include. The sky on this cover could have been inked in solid black, which would also have been dramatic. However, this would have left very little room for color. Use bold line work to make your drawing punchy and powerful. Remember, this cover has to grab attention!

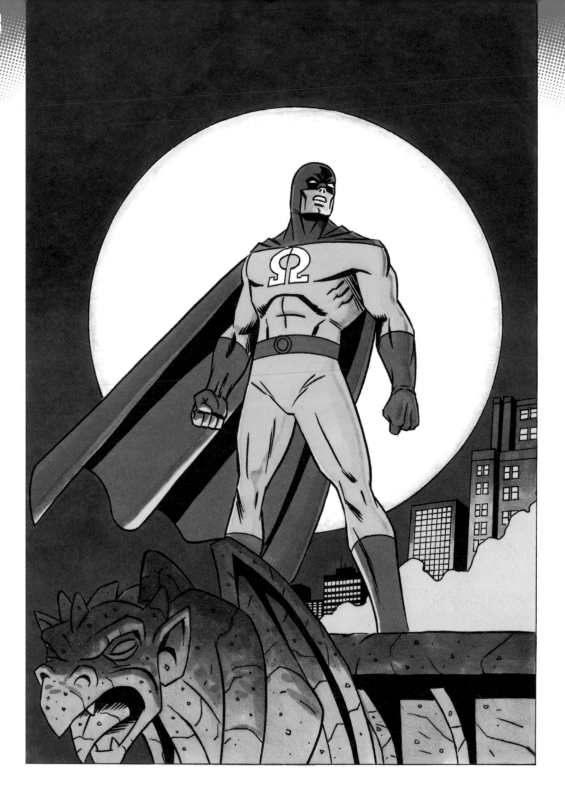

Step 4: Colors

Here we have the final hero cover, in color. Color is especially important on your cover artwork as it will catch your reader's eye. You can achieve this effect by using marker pens, inks or watercolors. We have chosen to keep the color palette simple, sticking to white and shades of blue and yellow.

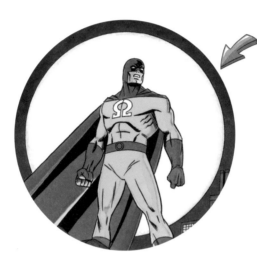

Light sources

The first thing to keep in mind as you start to apply color is the light source. In this image there are several: the moon, the street lights, and the office-building windows.

Heroic hues

The main body of the hero's costume is a very pale blue. Royal blue has been used for the cape, mask and gloves. Slightly darker shades of blue have been applied for shading.

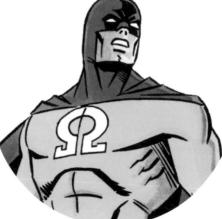

Moonlight

The moon itself has been left in white and acts as the perfect bright frame for the main character.

Street lights

Yellow tones have been added to establish the second light source. They are applied to create highlights on the gargoyle and to emphasize some outer areas of the hero's figure.

THE TEASER

The teaser cover is used in a similar way to the story cover, to give the reader a taste of what to expect within the comic book. The difference is that the teaser intentionally leaves out some information so the reader is left guessing.

Step 1: Roughs

Once again, we tried two different approaches before settling on a favorite.

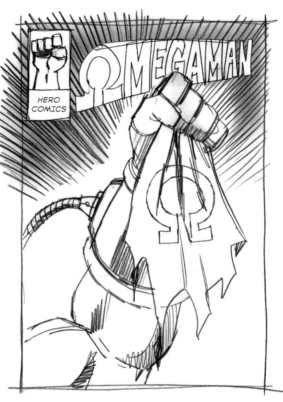

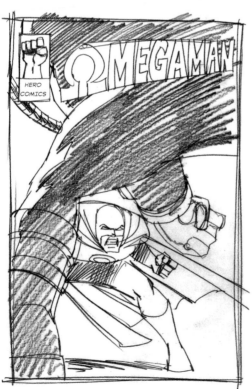

First rough

A muscular arm holds aloft an emblem torn from the hero's costume. It is left to the reader to wonder what has happened. Does this mean that Omegaman has been defeated? Has he even survived the confrontation?

Second rough

Here the villain is deliberately shown from an unusual angle and cast in shadow. This creates a sense of mystery. Readers might be able to figure out the identity of the villain by looking closely at the details on his outfit, but they'll have to work a little harder than if they were looking at a hero or a story cover.

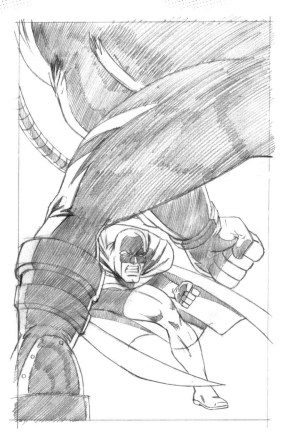

Step 2: Pencils

This final cover may be simple in terms of the amount of detail shown, but the perspective makes it look very different to the usual fight scene. The low angle and heavy use of shading make it appear that the villain is an enormous dark presence looming over the hero.

Step 3: Inks

You'll need plenty of ink for this cover composition! The villain is shaded almost completely in solid black and the hero is partly obscured by the position of the villain's leg. In this example, the inking stage is almost the most important one as there's very little space left for color. Despite its simplicity, this cover design will be powerful and dramatic.

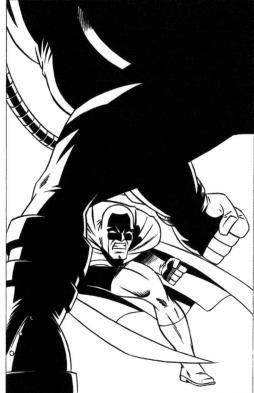

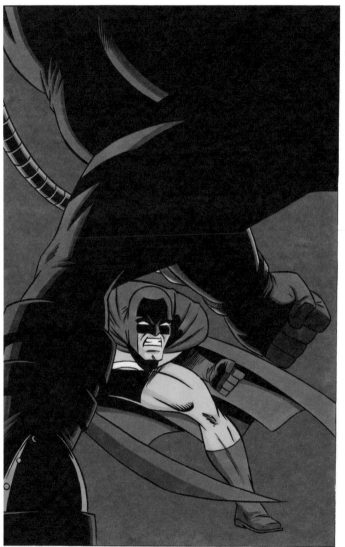

Step 4: Coloring

As this is a simple composition with a lot of heavily inked areas, the color palette must be carefully chosen to produce the most exciting effect.

Red light spells danger

We have chosen to use a bright, attention-grabbing red background for our teaser cover, which will contrast dramatically with the black ink. Also, as we're not showing any detail in the background, we can choose a color that's symbolic of the action. Red is often used to alert the reader to potential danger. It's the perfect backdrop for the battle between our hero and villain.

Here are some questions to ask yourself as you design a cover.

- Will your cover design grab the reader's attention?
- Have you left enough space in which to add the type?
- Do your colors work together and do they reflect the message you want to communicate?

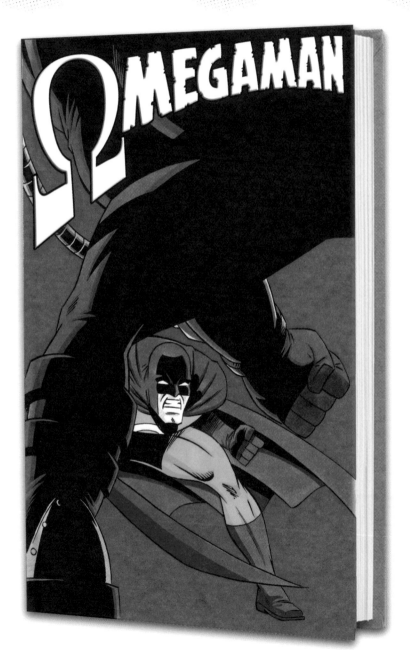

A SCI-FI COVER

The cover of a comic or graphic novel is its most important illustration. It's the advert for your adventure! if you break the cover down into its individual parts, you'll soon realise that it's less difficult than it seems at first.

Step 1

Start with the wireframe of your central character—we have chosen space pirate Xara. Then fill the rest of the cover with supporting characters. You can use other elements to create drama, as we have done with the spaceship and the giant enemy looming in the background.

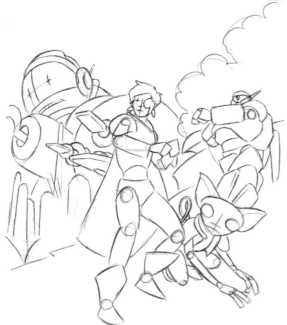

Step 2

Now flesh out your characters. Start with the foreground and work back, so that you know how much of any element is hidden by what's in front. Add some rough background detail, such as the building outlines and the billowing smoke cloud.

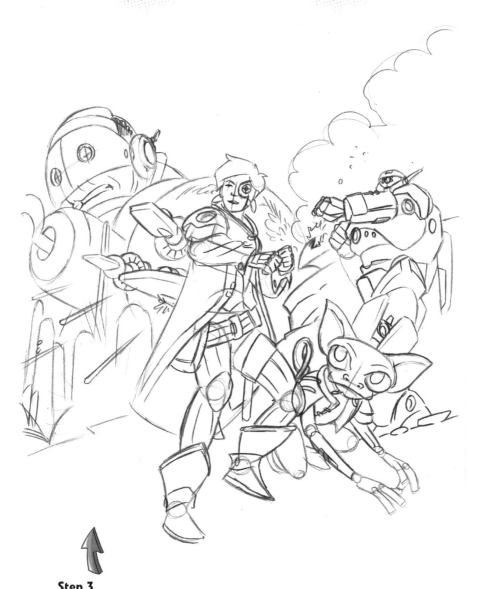

Step 3

Add more detail to your characters. The mighty mecha, Giganaut, has less detail since he is farther away. Dream up a face for your huge villain. Give the scene some action with a couple of missiles shooting past.

Step 4

When you add ink, be careful not to go overboard. A large scene like this needs less detail on the background items, so that they don't draw attention away from, or clash with, your main characters.

Step 5

The whole scene is brightly lit from behind by the explosions. Vary the color of large areas, such as the sky. We have left a space at the top for the title of the comic. What will you call your masterpiece?

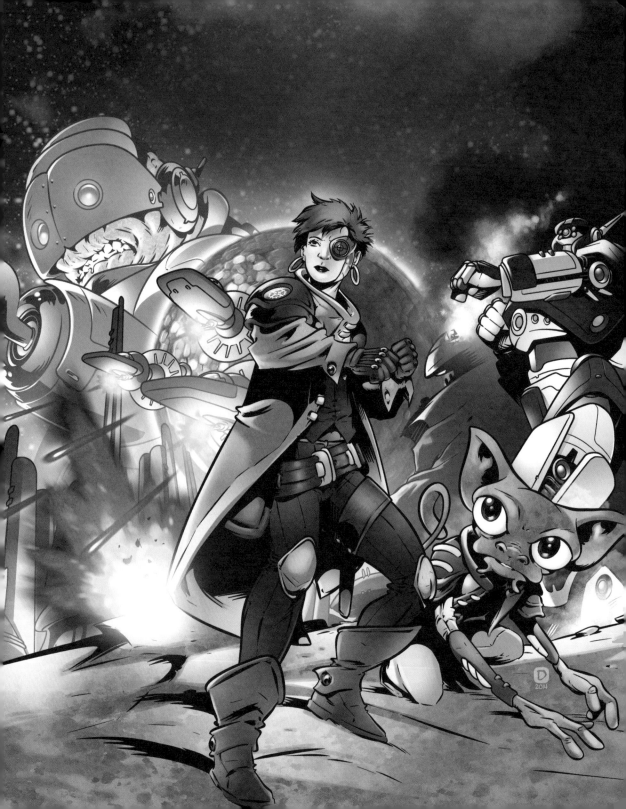

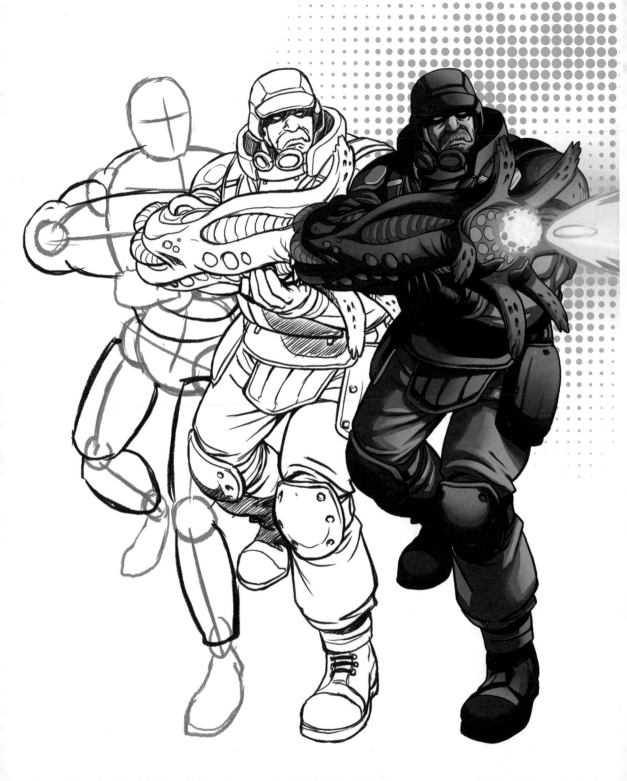